The White

The White

A NOVEL BY

Deborah Larsen

ALFRED A. KNOPF
New York
2002

THIS IS A BORZOI BOOK
PUBLISHED BY ALFRED A. KNOPF

www.aaknopf.com

Knopf, Borzoi Books, and the colophon are
registered trademarks of Random House, Inc.

Library of Congress Cataloging-in-Publication Data
Larsen, Deborah
The white : a novel / Deborah Larsen. — 1st ed.
p. cm.
ISBN 0-375-41359-6
1. Jemison, Mary, 1743–1833—Fiction. 2. Genesee River Valley
(Pa. and N.Y.)—Fiction. 3. Indian captivities—Fiction.
4. Seneca Indians—Fiction. 5. Women pioneers—Fiction.
6. White women—Fiction. I. Title.

PS3562.A729 W47 2002
813'.54—dc21 2001053977

Manufactured in the United States of America
Published July 19, 2002
Reprinted Once
Third Printing, October 2002

In memory of Christopher

The sky is pale margin. Neither flesh nor a god, it appears to dissolve at the firm edge of land where a tale might begin.

These edges of earth, muddy browns and flat blacks with offshoots of green, are marked and distinct and indeed suffer their distinctions, just as the Seneca language suffers its difference from English or French. Only the snow sometimes softens the world—its bulwarks, stiles, and mountain faces: that pier-head, this rigging, those docks beyond which lie impassable waters.

I was born a white at sea on the way to the New World. From my youth in that world I wished to own land bordered by sky, as my mother and father had once purchased woods and fields which were dappled with changing light. In time this happened in such a fashion, I daresay, as it had happened to few women before me.

But I was taken by those whom we called Indians. Nearly speechless for a time, I was beset by terrors.

My birth name was Mary.

CONTENTS

PREFATORY NOTE

IN 1758 a woman around the age of sixteen named Mary Jemison—or as some now think, Mary Jamison—was actually taken by a Shawnee raiding party in south-central Pennsylvania; she was forced from her home, which lay close to what would later be known as the town of Gettysburg.

In 1823, in New York State, the aged Mary sat for three days with a physician and local historian, James Seaver, and told him the story that he wrote down and then published. Some time after this meeting, she reputedly commented on it: ". . . but I did not tell them who wrote it down half of what it was." I imagine Dr. Seaver as a Latinist and a rhetorician. He writes of shots as a "discharge of guns" and of his heroine as able to "render herself intelligible on any subject with which she was acquainted."

A statue of Mary Jemison stands but fifteen miles from my present home in the woods. Some say that at a site not far from this statue, iron spikes and a single shoe buckle have been unearthed and that they belong to the vanished house that Mary's father built on the banks of a creek, the Conewago, which continues to cut the broad valley where this story begins.

Adams County, Pennsylvania

[1]

Buchanan
Valley

1758

MARY had loved the family axe as a glittering extension of her own arm. Her father had sharpened it the morning they were taken, and she had been splitting wood, cutting the thick white oak with ease, cleaving filamented piece from piece for the sake of warmth-filled evenings and for cooking. She imagined the flames tentative at first and then thrusting up, spending themselves in the foreign air for the comfort of her family.

And then for what seemed like no reason at all (because her father had said they could make it on their own until late spring, when the closest fort would send a militia to fend off Indian raiding parties), she saw feet in moccasins not far from the woodpile at the base of a shagbark hickory. She lifted her gaze to the impassive eyes and sculpted planes of what she would later learn was not an "Indian's" face but that of a Shawnee.

She spoke no word at this time, though a rage started up within her. So. Feet in moccasins.

So, feet in moccasins were now pressing into the very ground that belonged to her family, and she wondered how Father would explain them away.

How could he, how could he have left them as prey to what after all had hurtled across the horizon, to what with sureness had crept through their fields? No, he had actually *led* his family. How *could* he? How could he have led them, as it is written in Scripture, like lambs to the slaughter?

WAS IT for this that she had been conceived?

And born *Mary*, for so she had been born and named in the yellow air below-decks of the ship *Mary William*, out of Ireland, bound for Philadelphia. Thomas Jemison and the pregnant Jane Erwin Jemison had sailed out onto the loose, flecked fields of the Atlantic, preferring the clear American wilderness to the Irish civilization of the day. Away from Ireland, they would feel free to want something that was actually obtainable. They wanted a farm.

They landed; they moved straight on out of Philadelphia to a tract of land not far from what would become the town of Gettysburg. What they marked out as their farm lay on the tangled banks of a creek named Marsh. Later they moved to larger fields, on one of which stood a good house and a log barn, and it was here now where Thomas had let them all fall into the hands of six Shawnee and four Frenchmen and where his mouth had been suddenly stopped of his stories, of his resonant Irish jests.

This is how in April of 1758 a Shawnee came to be wearing her mother's indigo shawl; this is why Mary found herself watching a Frenchman pocket the family coins; why another Shawnee packed with great precision yesterday's corn cakes into a sling-like bag which he hoisted to his shoulder as they all took off across her beloved fields.

They just left, then, for somewhere that must have been north and west.

Mary was in the grip of a Shawnee. She was not dead yet, but she knew that if she didn't move fast enough he could simply cut her down and away. His companions would understand what he meant them to know by means of a mere flashing of his eyes in her direction: too much trouble, those eyes would signal; too much trouble, the white girl, too slow.

She closed her own eyes then and stumbled along, deciding to give her captor that trouble. He felt it; he jerked her and then jerked her hard again, as if she were a snag on his fishing line. She didn't care.

Let him jerk her, let him jerk her arm until it hung loose at her shoulder, and then dressed as he was in her mother's shawl he could shoot her or split her skull with his hatchet.

She heard her father's voice: "Mary."

"Mary," he said. "Open your eyes. Watch where you are being led."

Then the young Irishwoman opened her eyes and saw them all—her parents; her brothers, Robert and Matthew; her sister, Betsey; the neighbor and her three children. Then it was not so easy for her to be stubborn, to ask for death; to see them moving far off ahead of her now into the woods she had named for her cow: Boss's Wood.

Besides, if she was to die she didn't want Father's back to her, she wanted him to see her die, to see: let him see and behold where all his good cheer, where his cracked optimism had got them.

CAPTURED by the Shawnee raiding party and headed out across her family's fields.

The fields stood in the mild April sun looking just as they did before her capture.

Mary stared: how *could* they look as they did? And she answered her own thought: because, the fields are just themselves.

AT THE time of the French and Indian War the south-central Pennsylvania fields sometimes curved halfway up hillsides. With the unseen roots of a thousand things—wild onion, wake-robin, common grass, the corn and flaxseed her father had sown—the soil was held close to the gray shale that made up the sweepings of land. From beneath the rock, the earth's pull kept the heavy red clay from flying up into a skv marked by scuddings of clouds.

BEFORE her capture, Mary had begun to think that although some things of fields—lilies, vines, choking patches of weeds—are mentioned in Scripture, yet they are not Scripture. The things of the fields are themselves. As Scripture is itself and holds only a partial account of the murderous, of good will, and of their frequent twinings.

God, she had ventured to think, may have given her the New World fields to balance the Scriptures and as a perfect refuge from the Presbyterian catechism.

"Consider the lilies of the field," the Scripture said. The lilies did not toil nor did they spin, yet even Solomon "in all his glory was not arrayed like one of these." And the lily lives just as it did in Israel, even though it has never brushed up against so much as one page of Scripture. That alone could keep her from going mad.

The lily in a field was a fact. For, she had thought, not even Scripture—in all its glory—was arrayed as one of those.

NOW THE party was on the run. The Shawnee and the French were brutally intent. They forced the colonists through sucking spring mud, over logs, up and down hills. At first the captives ignored low tree branches and the spiking shrub undergrowth pulling at their clothing, scratching their skin; toward the end of the day they felt even one brush of the smallest twig as insupportable.

A Shawnee lifted a restraining hand. The light was going; the shadows of the hemlocks began to lose their definition.

The neighbor's son whined that he was thirsty. Two Shawnee looked at each other: one stepped aside, urinated into an empty box turtle shell, and offered it to Daniel. Mary took a step forward to protest, but her mother stopped her, saying only, "Mary." The boy himself had already begun to drink, the thin curves of his lips at the uneven edge of the carapace, the urine spilling a little down his chin.

The captors spread a few boughs about; the dank

ground was to be the communal bed for the night. There was no fire and no supper. Mary and her mother put the young ones between them; Thomas lay down somewhat apart, sighed, and rolled over, facing away from them.

The younger children drifted off. Occasionally, Jane would reach over them and touch Mary, whose moments of sleep were few.

As Mary had grown older she had been allowed to stay up late at night and converse with her parents and other visiting adults, one of whom had told of his brother who had been tortured by Indians and had somehow later escaped. Small cuts had been made all over his body; into these slits pine splinters had been stuck and then set afire.

In the nights at home she heard wild animal noises and worried that these sounds came from the throats and cupped hands of Indians. When the next day her family would find entrails, the remains of owl or bobcat pillage, she would be relieved. The noises had come from real animals.

At the same time, her relief made her feel guilty: was not the bobcat as an Indian to the possum; was not a great owl an Indian to the vole? Did not the possum and the vole feel terror and pain?

THE NEXT morning the Shawnee and French parceled out bread and a little meat from the Jemisons' own provisions. Thomas received his portions into his hands, but then opened his fingers and finally turned his palms down so that the morsels fell to the ground.

"Thomas," his wife said. She looked at his piece of meat, at his piece of bread; after a moment he moved his head and followed her gaze, but his expression did not change.

His eyes, Mary thought, are as fixed as the eyes of a newly dead person. She positively didn't know him, she decided. This man, whoever he was, meant to die and leave them. What good was he to them anyway? What good could come of a man who in mere moments had turned passive, a man who had mentally abandoned his family?

In her contempt, she felt more capable of pity. He had become a child. He was almost her child now.

"Thomas?"

He looked at his daughter. She had called him "Thomas."

"Thomas. You should eat."

And Thomas, as he had been ordered to do, picked up the piece of meat and began to lick it with the approach and in the manner of a cat.

One of the Shawnee stepped out of the woods and spoke a sentence. He had backtracked, scouting: the whites from the valley they had just raided were in pursuit. The Shawnee spoke again, this time a mere phrase.

Another Shawnee thrust corn husk moccasins into Mary's line of sight. Then he bent, pulled off her shoes, and replaced them with the moccasins. When he had straightened, he gave her a look which said that what he had done was significant.

She turned from his look. How dare he? Whatever he meant by it was secondary. What she hated was that he was there at all, that he was real and meaning anything by such an expressive look.

But the Shawnee turned also from her and was already placing moccasins on Daniel's feet.

And her mother suddenly stiffened, sensing impending separation. She spoke out in a rambling way, saying that it might have been better if her child, Mary, had been stillborn; that had the infant girl died, the loss would have been sweet compared to this capture and this manner of parting.

Then Jane seemed to recover herself and, whispering, she addressed Mary directly. "You will have to be strong now. Remember three things."

A Frenchman and a Shawnee gestured to Thomas to get up.

"Do not," Jane said, "forget your English."

13

Now the raiding party had roused all the whites.

"Carry us," her mother continued, "in your heart with your English and the Scriptures. And, Mary. Do not cry."

After they were led away—the father, the mother, Matthew, Robert, Betsey, the neighbor woman and two of her three children—one of the Shawnee squatted. He became fully absorbed in regarding Daniel, and then Mary.

IN A marshy area about a mile from where Mary and Daniel were under scrutiny, the party of whites led off by the Shawnee and the Frenchmen were brought to a standstill.

Since the light was going, both the bodies and the long knives being thrust into them were silhouettes, as were the captives' heads and the rifle butts which hit them and the tomahawks which sank into them. It would have been hard to see that the long hair a Shawnee finally wrapped around his hand was a rich auburn color.

MARY opened her eyes and saw that it was morning. All were asleep—Daniel, the Shawnee, the Frenchmen. Her mother's blue shawl lay on the ground. Where her mother had left it? Where the Shawnee who was wearing it had left it?

SETTING downed grasses up as he went, one of the Shawnee ran backward. Forward of him, Mary and Daniel were forced to run through the reaches of underbrush.

ABOUT a year earlier, on a cloudless day, she had climbed up a hill and then had decided to try walking backward on the top of it. Her dog, Molly, had noticed and had evidently hated it, had barked in great anger to see what seemed an unnatural and unexcellent aspect showing itself in the young woman who was her mistress: this walking backward. Shaking herself, Molly had barked: stop this, stop this; stop this thing, these doings.

ON THE third night out they were among thickets and drank a dense, cornmeal-like liquid which did not taste of cornmeal. She pinched the skin above her thumb to

try to stop her tears. She pinched again and again and harder and harder until she drew in a breath with each sharp pinch. Her mother had told her not to cry.

But she had cried anyway and now she felt ashamed; she must redeem herself in her absent mother's eyes if not in the Indians', who, surprisingly, seemed not to care if she cried. They only wanted her to hurry.

Two of the Shawnee opened a deerskin bag and took out flattish, curved objects. Scalps cut from flesh, damp as they are, soaked with blood, spoil easily. Two Shawnee set them out near the fire with some hoops fashioned from saplings. Now they deftly stretched the circumference of thin skin at the edge of the scalp over the hoop and held the whole to the fire for a time for drying. Next they trimmed any excess of skin away as if it were a scrap of savory-pie crust.

They were careful: no bit of soft tissue escaped the knife's cutting and scraping. Later, they combed the scalp hair and painted it red. But they did not paint her mother's hair, for it already partook of the color red.

In this manner, Mary beheld the cloven flesh of her family; she could distinguish scalp from scalp by means of the differing patches of hair.

As it was written, "The very hairs of your head are all numbered." But where was the God who, implying extravagant concern, had said that? Where was He who kept count of all the hairs of all people? Where was He now?

17

Daniel asked what the Indians were doing, but Mary turned her whole body away from the fire.

The young-looking Shawnee with the auburn-haired scalp turned it admiringly in his hands. In Shawnee he said, "Rare." He said that it was perhaps a conjuring scalp, and he thrust it in the direction of Mary's back and then raised his voice and said that a reddened head could conjure.

But the prisoner gave him no response. Angered, he shouted at the young woman's back. "Reddened head," he barked. "Reddened head! Reddened head could conjure."

Her mother, Mary decided, had been right: better to die than to endure this. And her own first instinct had also been right when on the day she was taken she had not cared about being killed. Let them, just let them, she had thought. She should have died with her family.

In this fashion, she came to the decision to tell her captors that her life should be taken.

"I want to die."

The Shawnee and French, smoking tobacco and sprawled about on the ground, looked at her.

She raised her voice. "I wish to die." She swallowed, grasped her own long hair, pulled it up high above her head, and with the other arm made a swift cutting motion at the level of her scalp.

A Frenchman sat up.

She addressed him and repeated, "I wish to die. Kill me." And then she said, "Please."

The Frenchman turned to another Frenchman, who turned and said something undecipherable to a Shawnee. Then the second Frenchman said in a laconic manner, *"Non."*

"Please."

"Non," said the Frenchman. *"NON."*

After a while, the oldest Shawnee regarded Mary and then spoke briefly to the youngest Frenchman, who in turn approached her. He tilted his head and stared down at his boots as if they would speak for him. Mary also directed her eyes downward.

Finally he looked at her and tried to tell her that earlier too many prisoners had been slowing them down, that other whites were probably in pursuit of the raiding party by now, that it had been necessary to kill some of the captives.

He threw out his arm as if to gather up, to embrace the taut scalps on their hoops. *"Absolument nécessaire,"* he said. As if he were speaking to one who could not hear, he raised his voice. *"ABSOLUMENT NÉCESSAIRE!"*

Mary's gaze was still fixed on his boots, so she did not see him turn toward the oldest Shawnee and shake his head.

＝＝

Since the party was diminished, it moved more quickly the next morning.

Mary now took the short steps she had been made to understand she should take. The simple repetition, the quick laying down of one foot and then the other would help her inure herself to thought and feeling. Walk, walk. One foot, the other.

Don't think, she thought. Don't think, don't think; do not think. Be part of this whole; let it rush forward, let it rush you forward, be part of the sky and the ground and of the inevitable progress of this raiding party. But do not think.

With his hand, one of the Shawnee brought the column to a stop.

Mary was aware of trees here and there and then a break and more trees and breaks and then the sound of water.

A Shawnee said, "Monongahela." The Falling-In-Banks.

"Monongahela," one of the Frenchmen said. "*Et* Allegheny."

"*Mon Dieu,*" another Frenchman sighed. He leaned toward his compatriot.

"Duquesne," a Shawnee said.

In a makeshift shelter just outside Fort Duquesne, candlelight bobbled and spilled into the woods and onto the poison ivy; the light made the curls of the

shagbark hickory throw shadows. The candles leaked their yellowy wax onto the crude table at which a Shawnee stirred carnelian paint and appraised it and again stirred it.

Mary and Daniel had been brought to the lean-to, and they stood together and watched. Finally, the Shawnee appeared satisfied with the results of his stirrings; he picked up a rag and beckoned to Mary. His gesture was an odd, jerking, snapping motion of his wrist and hand. She moved forward.

She had withdrawn her energy from the consuming fire of hurt and anger. Let him tell her what to do, let him do as he wished, let him do anything; it didn't matter if he touched her, let it be a blow, let it be anything: let it be death.

The man sat her down on a stool in the light, dipped his rag in the thick red liquid, and began to paint her face. He started at her hairline and painted the temples first and then the forehead; he worked the paint down between her eyes and down the nose, then up to the cheekbones; at last he dipped the rag again, lifted it to fill in the cheeks and chin, and then swept out left and right to cover both jawlines.

He gestured to Daniel and then began to paint the boy's face and hair. When he finished he got up and grasped a strand of Mary's hair, saying that it needed no paint. No, it had its own red.

And then they heard the sound of the cross-fenced door of Fort Duquesne swinging open.

Light from sludgy torches illumined the fort as the raiding party and its two prisoners entered. Groups of French and Indians looked on; two women who were Seneca moved up to see Mary at close range as she passed through the little crowd.

Inside a small room in the fort, one of the Shawnee turned to lock them in and leave them. Mary's gaze was fixed on the deerskin bag he had slung over his shoulder. He noticed this and spoke. "You want to see?" He started to reach into the depths of the bag.

Mary turned away and left him staring at her back, so he shrugged, let the short flap of the bag fall shut, and went out of the door.

"Those were the scalps in there," Daniel said. "Did you want to see them before he took them away?" But she made no reply. He started to cry. She did not or could not make the effort to respond; she would have to abandon him to whatever inner strengths he had.

In the morning, a Frenchman who was not part of the raiding party came and beckoned to Daniel. Then he said to Mary, in heavily accented English, "As for you, today you will find a new home."

Mary roused herself long enough to ask where they were taking the boy.

The Frenchman stared at her. "*His* new home," he said.

"Where?"

But the man did not respond. And then they were gone. After a few moments, Mary stepped over to the door that had just closed and touched it.

She would never see Daniel again, nor would she hear word of him.

Later the door opened once more and the two Seneca women, sisters, who had looked closely at Mary the night before entered and merely observed her: her painted face, her chestnut hair, her freckled forearms, her torn clothing, her moccasins. The two sisters turned to each other. Finally one said to the other, "The shape of her face is a little like that of our brother's."

THE SHAWNEE who had been in the raiding party pushed their canoe into the shallow water. In motions that seemed synchronized they stepped into their bark and paddled out onto the Ohio. The two Seneca sisters, who sat with Mary in a smaller canoe, followed behind.

In the forward canoe, a Shawnee stopped paddling and pulled a skin bag to him. He opened it, took out scalps, and began to fasten them to a cut sapling, to string them as if they were pennants. Then he lifted the flexible pole to his shoulder for a few moments and carried it as if it were a yoke. A small wind blew across the water; the scalps moved back and forth, the hair fanning out.

Mary, at mid-canoe, turned her body away from the sight as much as she dared in the narrow confines of the birch bark. The older sister lifted her paddle and held it out in the air.

"Look," she said in Seneca.

The younger sister glanced back and then in the

direction in which the older sister had pointed. A heron stood on one foot on the shore.

"Heron," the younger sister said in Seneca. And then she called to Mary, again in Seneca: "Heron!"

Mary sat unmoved, turned away, slumped down in the skin-blanket the sisters had given her.

The party of two canoes came around the bend. From a point about a mile down the river, smoke drifted up and entwined with the overhanging mist.

When they were almost parallel with the smoke, they saw, close to the water, forked sticks supporting a long pole on which hung the remains of several persons. Most of the body parts were roasted and burnt black; here and there they could make out a head, a leg, an arm, or some other fragment. Small flames sprang up and up and tried to fuel themselves with those body parts which were closest to the ground. On one charred finger, Mary thought she saw a gold ring.

The captive closed her eyes. The sisters put their paddles back in the water and swiftly turned the canoe away from the scene.

MARY had managed: she had succeeded in install-
ing in her mind the great, pale blankness of non-
thought. It was an actual thing, that blankness: it hung
there like a great pearly fish in deep water; it hung un-
touched by a sky the color of purple. By dint of the
slow-motion lashings of its massive tail, this fish con-
fused, unhinged, and scattered both certain idea and
clear feeling.

[11]

The Ohio Valley

1758 - 1762

THE LIGHT was giving over when the sisters swung the canoe toward shore. Cryptic shadows shimmered in patches either on the river's surface or just beneath it. The raiding party canoe paused, and the Shawnee who had the pole of scalps lifted it above his head and then lowered it. And lifted it again in farewell. Mary turned away.

The larger canoe then headed out down the river by itself as the sisters ran their own boat aground, gestured to their passenger that she should remain, and made their way toward a cluster of elongated houses.

When they returned, they carried steaming cloths and a bundle of clothing and helped Mary out of the canoe. In the chill of the April night they undressed her, put aside her rags, and carefully washed her body.

A broadcloth petticoat came slipping over her head, the sudden warmth of it. And then more warmth—a long-sleeved flannel gown, a shirt that had neither collar nor sleeves. And deerskin strings everywhere—strings at her waist and strings to hold up the stockings which

reached from her knees into the mouths of her buckskin moccasins. They finally placed a blanket around her shoulders.

Within the silent village, its people regarded the young white woman. The sisters signaled to her to enter one of the houses. Burning beneath a vent hole, a small fire wavered. In spite of herself, Mary coughed. One of the sisters motioned to her to sit down. The hut began filling with women.

As the captive sank to a sitting position, a woman began to sing. She sang of the dead, and in the moments when she paused to take breath, sighing sounds arose from the others.

The singer then looked purposefully at the two sisters and sang, with many short pauses, of their brother who had been recently killed by the whites:

> Light Bear lay in a dusty field
> staring up at a yellow sky
> after a battle in Washington's war.
> He imagined his sisters,
> the ones of the glossy hair
> and the slender, strong arms;
> he saw their old home
> on the shining banks of the O-hi-o.
>
> Thus Light Bear lay until a white
> cut short his thoughts

by kicking our wounded brother
and crushing his rib box.

Then did this Seneca's spirit
startle, then did it hastily
pack, then did it gather itself
to take leave of the body.
Then did that body sense
that soul's withdrawal
such that it recoiled,
such that it started to wilt.

The jaw became fixed,
the limbs grew rigid
as sticks, a thumb
stopped twitching.

For all we know
the bones lie unburied—

Here the singer stopped because the women began
to cry out. She waited for a time and then began
again:

Light Bear had no comforts,
those objects of burial:

no candles for dusk,
no gleaming tomahawk

31

nor war suit of clothes,
no little cakes
nor arrows to show off
to friends in the afterlife.

We mourn for our brother,
we long for his presence.
But his drum-like voice
has been torn from us.

In his place sits this captive
of no little beauty.
Her nose is shaped
just the same as our Light Bear's.
His sisters choose to adopt her
and call her their own.
May she be happy
as long as she lives.

Then she dropped to her knees, lifted her arms in front of her, and positioned herself before Mary. She ceased her singing and began to speak. She said that the two sisters' dead brother by means of earthly and just trading practices had sent them a helper, the white woman they saw before them, and that her new name would be Two-Falling-Voices. Two voices, two pitches, two slopes.

A murmur rose from the group; the older sister extended her hand to Mary, helped her to her feet, and said, "May you be happy as long as you live."

But the newly named white who stood among them in exchange for a dead warrior understood none of what had been said, nor did she herself speak a word.

FINGERLINGS of green leaves had uncurled close against the branches of shrubs and trees, but the captive paid them no mind. She followed instructions only, learning her sisters' methods of planting corn.

As she sowed, two series of images began to occur to her. She saw actions only and did not reflect on them.

In the first series she saw that she had unlaced and unwound all the clumsy strings which braced her clothing and her stockings; she tied them together, wound the ropy length around her neck, and hung herself.

In the second series she saw herself slip silently, like an amphibian, from the shore into the drowning-depths of the Ohio River.

HER SISTERS decided she should accompany a hunting party from time to time, especially when the men were going just a short distance. Mary could be useful in helping to carry the game back; but in this way, they hoped also that her bad spirits would be affected. To go to the woods and see elk, deer, muskrat, and beaver moving about and to follow these creatures often resulted in people brightening, finding that their sad ruminations had stopped.

The black of night had waned just enough behind the alders so that trunks and branches began to reveal themselves. The small group lay on their bellies on the earth.

As soon as the prey appeared an arrow flew; a buck jerked its neck and fell. When the group rose to move up the hill, someone motioned for Mary to follow. By the time she reached the deer, one hunter had started to gut it.

In the village this man had often regarded the newly adopted young woman in a kindly way. Both his legs looked as if they had in the past suffered burns. With-

out stopping his slitting work, he managed to glance at Mary.

"Once we have killed and need to cut, we cut quickly," he said as if he were speaking to himself.

Mary looked at him.

"Very quickly," he said. "And with force."

She watched his eyes.

"Now," he said, "we will draw out the bowels."

Before she and the others hoisted the carcass, she had bent merely to touch it. Blood brought a warm coating to her fingers.

The man who had done the gutting said to her then, "No time can be wasted when the hunt is going on."

Mary looked at him but he had already turned away.

AS IF in a dream there were trees wound in mist again and then an outline of a hulking shape: the fort, now named not Duquesne but Fort Pitt, since it had been taken by the British. The Seneca people had been invited to come and discuss a treaty.

In this way, Mary revisited the scene of her imprisonment.

Inside the fort there were groups of British this time instead of groups of French. Two white women stood together with a little girl. They, all three of them, studied Mary. Then one woman took the little English girl's hand but smiled right at Mary and said, "Hello." She paused and said in a louder voice, "Hello." And then, "What is your name?"

Mary looked down at the small hand with its fingers curled around the larger hand.

"You were, perhaps, captured?" The Englishwoman waited, and after a moment she thought the silent young woman lowered her head in what could have been the smallest of nods. Then she asked Mary where she had been captured, and to this question she received

no response at all. Leaning forward, she tried again: "What is your name?"

And Mary said, "My name?" Then she took a step backward.

"Yes. What is your name?"

"My name is—Mary."

At the answer for which she was looking the Englishwoman surprised herself by raising her forearms and spreading her fingers as if to ward off a blow. The unimaginable had indeed happened.

Mary felt a hand on her arm and allowed herself to be led away by her older sister. In minutes they were out the door of the fort, in a canoe, and crossing the river to their temporary encampment. She stood as her sisters took their half-baked breads out of the coals, gathered up their belongings, rushed her back into the canoe, swung out, and headed downriver, back toward their village.

WHEN the Englishwoman had raised her arms, Mary had smelled sweet woodruff, that woodruff of the whorled leaves. The woman had thin, gathered silk at the neck of her dress and at the edges of sleeves that fell to her knuckles.

Mary saw images of the rooms in which that family lived. The mother would keep things neat and mend

her family's stockings. All of them took hot baths once a week; they owned soap and a sponge. The daughter, young as she was, could cipher, could in fact write all the numbers and letters. In the evenings, the family would speak in English about the puzzling parts of the Bible.

The child's father was a doctor of physic, and when his slim fingers were not probing deep into pulsing wounds for arrowheads and bullets, they served as a scaffold for playing cat's cradle. This father, the doctor, had not taken his family to southwestern Pennsylvania.

"Southwestern Pennsylvania? My God, man," he would say to a friend who had asked his advice, "that frontier is too fragile, much too exposed. If you value your wife and your children, wait until settlements are thick in the region, until a fort rises in that valley.

"Much too risky," the father who was a doctor would say as he walked away.

And then he would come back to make his point emphatic, for he loved his foolish friend. "What can you be thinking of? Put the idea behind you. Promise me."

MARY's sisters, Branch and Slight-Wind, their eyes wide, paddled relentlessly, paddled as if the shores of the river were closing in on them from behind.

IN THE next days, lines fraught with images came to her from the Scripture and repeated themselves: ". . . For my days are consumed like smoke, and my bones are burned as a hearth . . . my bones cleave to my skin. . . . For I have eaten ashes like bread. . . . For my days are consumed like smoke and my bones. . . ."

SHE DID that which Branch told her to do; she took all of Slight-Wind's suggestions. The sisters looked for signs of at least momentary happiness in Two-Falling-Voices; they looked for frowns, for the softening of the eyes that comes with wonder; they looked for rapid breathing, an impatient movement of the hands. They looked in vain. She was almost completely devoid of gesture. Her face was blank, her voice was low and without inflection, she answered questions with the shortest of phrases. They never saw her weep.

When light the color of wheat touched the tops of the hills, she did not appear to notice. The children's chanting games did not charm her, nor did the nonsense talk of babies. Barking dogs did not cause her to turn her head. When she had free time, she walked a short distance, sat unmoving among the white oaks,

and looked up through the spaces between the clusters of foliage. She ate little.

Though Branch was always kind, she sometimes grew impatient with this persistent and bland behavior, for she sensed that her new sister had once been otherwise. "I know she has sorrow," Branch said to Slight-Wind. "But sometimes I believe she is thinking about nothing except her plans for escape. And sometimes I think she is acting this way out of scorn."

Once when Branch was especially impatient, she turned to a friend of hers and said, "I think she is hollow inside, as a dead tree grows hollow. Let us pretend that instead of adopting Two-Falling-Voices we had decided to take her life. No matter how hard or in what place we had laid the hatchet to her body, we would not, I am certain, have drawn a single drop of blood."

"Her skeleton," the friend said, "is beginning to poke through her skin. Look at her elbows. Look at her kneecaps."

The next day the friend returned. "I think," she ventured to Branch, "if I were you, I would turn to the Society of False Faces. I know you think they have gotten away from some of the old False Face ways. But you need to do something quickly."

MARY woke to the presence of three masked figures carrying small drums. When they saw that she had opened her eyes, they started to howl.

She sat up. Almost immediately she knew she was not dreaming: her new sisters had positioned themselves in reassuring fashion at the door of the hut. And when she looked down she recognized the thin, burn-scarred legs and disintegrating moccasins that belonged to the Seneca who had shown her how to separate the deer from its befouling insides.

His mask was both hugely wide and elongated; it had a thin, bent nose and was black with red ovals of tears painted on its cheeks. The open mouth was formed as an almost perfect "O." The wearer of this Weeping-Face had craned his neck when he started howling, and the mask was thus tilted up as if it were a shield against whatever might lurk in the air above.

The mask on the second person was smaller, the face painted red with black streaks running from beneath the cheeks up to the outer corners of the eye-holes. Just above the chin were the lips, the lower one

protruding much more than the upper one; these were widely parted so that the appearance was one of an open-mouthed pout.

The third mask face was completely red except for black eyebrows on the broad forehead; these eyebrows slanted down toward those corners of the eyeholes which lay next to the nose. The mouth's lips were also parted but turned down in anger or disgust.

The Pouting-Face masked man stopped his howling and began to circle the remains of last night's cooking fire, into which Branch before retiring had unaccountably thrown some tobacco. He scooped up a good quantity of ashes, brought them to where Mary sat, positioned his mask mouth on a level with the ashes in his hand, and with great force blew them in her direction. She sat unmoved.

Then Weeping-Face and Scowl-Face pulled off the blankets they were wearing. They sank to the floor and rolled about, after which they got up, calmly picked up the blankets and threw them over Mary's head. And they began drumming a very light drumming. In the course of this drumming, the blankets shook: Mary sneezed; then she sneezed again.

"A good sign," Slight-Wind said to her sister.

The drumming stopped, and Weeping-Face and Scowl-Face began to sigh and then to wail. After a time, with a flourish they plucked the blankets off Mary and observed her. What they observed did not seem to sat-

isfy them, and they once again covered her with the blankets, only to pull them off, look again, and cover her again.

Finally Scowl-Face said, "A waste of our medicine." But Weeping-Face said, "She may not be ready."

Half an hour later, Slight-Wind said in a low voice, "It isn't working. The guardian spirits' image-masks aren't working."

Branch was chewing on her lip.

"Branch? It's not working."

"I heard you."

"You don't think," Slight-Wind whispered, "that she's some evil spirit, do you?"

"Of course not. Why do you say a foolish thing like that? She may be resisting us, but she is not evil. She is our sister."

"What will we do next in order to help her?"

"I do not know."

TWO MONTHS passed. One day Mary and her sisters worked cutting thin strips from deer hides. Mary went about her work with her face down. Her sisters watched her and exchanged looks.

Mary continued to cut. The deerskin resisted the knife she had been given, and as she pressed the blade its handle rubbed the skin between her thumb and forefinger. She had no calluses in that place. A small amount of blood first gathered and sat in the raw space and then, as she paid it no mind, spilled down the inside of her small hand.

When the blood began to drip onto the deerskin her younger sister looked up and then touched Mary's arm. She said, "You bleed."

Mary first looked down at her sister's hand and then held up her own hand almost to eye level and looked at it as if she could not imagine how it had come to be there.

Her curiosity led her dangerously close to a thought.

Her hand hurt. It was strange.

To whom did the hand and arm belong? A narrow carmine ribbon wound its way down past her wrist.

"A small wound," she said in English.

And then in English she said, "Blood."

No one spoke until Slight-Wind said, "Blood?" in English.

Mary touched the blood with her left forefinger, which she then rubbed against her left thumb.

Branch said to Slight-Wind, "I forbid this. We speak Seneca here." She rose and left the hut.

Slight-Wind also rose, and took Mary's hand firmly in hers. "Blood," Slight-Wind said in English.

IN BLOODLETTING, some say, Leviathan-like fevers are broken. And if so, what of the power of the naming of bleeding and of one's own blood: this is my blood.

What of the power of hurt? And what, in the midst of that, of the power of someone's unexpected touch and of their saying the one right word?

The word was "blood," the blood was mine, the skin rubbed away by the cutting tool was mine, the pain was mine, the fingers were mine, the hand held by Slight-Wind was mine, the arm was mine, the body belonged to me alone.

In grasping the fact of my flesh I began to think again. My flesh was as a field: it had persisted in spite of me. I began to think more distinctly, it seemed, than I had ever thought before.

I came to grasp what I had merely come to know: that the people with whom I lived were not Indians but Seneca, that I was already speaking Seneca, that I had been captured by Shawnee but given to Seneca, that my sisters had lost a brother to the white colonists. According to custom, I stood in a brother's place, though I may just as easily have been scalped, since satisfaction and justice came either through the taking of life or by means of adoption.

THE SENECA broke camp and sailed up the Ohio to a place called Wiishto, where they planted corn and then settled into summer. In time they were joined by a party of Delaware who had brought five white prisoners with them.

So she spoke Seneca and she spoke English, out

of her older sister's hearing, with the whites. Her thoughts in both languages increased as she tended the bearded corn. She also taught her younger sister some English.

MARY sat with the white captives one evening when Branch had gone on a short journey. As she drew near to their fire (for some one of the Delaware had out of kindness given them this separate fire), she heard one of the two men speaking and she stopped still.

"And next the farmer came to a tiny drawbridge, sure, and he saw that it had been pulled away to let a boat pass, but he thought this was passing strange since he could see no little boats anywhere on that blue-green thread of a river. And the farmer said to his nag, whose name was Coinn, 'Now, Coinn, look at that drawbridge. Just what in our Holy God's name is it doing agape like that, do ye think?'

"And Coinn opened his mouth and in the moonlight showed his great yellow teeth, but for all that, he either did not know or would not say what he thought, for Coinn was no talking horse but one who paid mind to his business: he had opened his mouth to show that he had heard. But now he closed it again. He was a thoughtful, sensible horse.

" 'Now, Coinn, we must close the wee drawbridge for sure, that's sure,' the farmer said."

———

I felt a pang and wondered what it was. It was the nausea of the sickness for home and for the storytelling times of home.

"BUT BEFORE the farmer could return the bridge to its proper place so that it should span the little river and people thereabouts could go back to their crossings, he shivered because he saw something moving on the water and it was no boat at all now. It was a very corpse that was coming floating along down that river, as if it belonged there, as if it was just out for a bit of a trip. And the corpse was all puffy, but it was shining bright under the moon so that it even caught the rheumy eye of Coinn.

" 'Coinn,' the farmer said, 'do ye not think that dead body there that is leaving a gleamin' wake in the moony waters looks a bit familiar, now?' And Coinn, sure, said nothing, but he rolled that eye of his."

One of the white women broke in and said, "Don't be talking to us of corpses, Dwyer, this night of all nights."

"Just wait," Dwyer said. And then he said, "I won't be telling you the rest until tomorrow night."

"What now? You won't be telling us the rest?"

"Not I," said Dwyer. "You have to wait until tomorrow night."

"What if we're not here tomorrow night?" the other man said.

"You'll be here tomorrow night in any case," said Dwyer, and he turned a kindly eye on all of them.

AMONG the Delaware at Wiishto a man named Sheninjee was the leader. He was taller and leaner than any man Mary had seen, and he moved quickly, always, but carried himself with grace. He was often silent, appraising, and sometimes critical. She watched him struggle to rein in his temper.

And she watched him look at her with his scanning eyes, with eyes of obvious judgment.

A friend told her that Sheninjee had said he saw two of Mary and when the friend chided him for drinking spirits Sheninjee had said no but that he saw twins and that she was aptly named: the white woman and also the Seneca woman. Two-Falling-Voices. Like an earth-hill under the sky that had two downward slopes.

But Mary said that Sheninjee had no right to name her or appraise her, that it annoyed her to have him speak in any manner of her, and as she spoke, her own words were a source of great surprise to her.

For months and months I had felt practically nothing, and now this, this thing, this thing like a speech that seemed to be almost an outburst.

MARY was scraping the damp flesh from a buck's skin when Slight-Wind touched her on the shoulder. "Come."

"Where?"

"Come with me."

Outside the hut people were half-running, as if thrust forward by some force; they streamed across a small field and up a hillside. Mary and Slight-Wind fell in with them.

When she reached the top of the hill, it took Mary some time to make sense of what she saw—a group of men crouched over but perfectly, unnaturally still.

"What is this?" She stiffened. "Is someone going to run the gauntlet?"

"Sticks!" said Slight-Wind.

"Sticks?"

"Look."

But first a great noise began. Mock crow calls. Brays. War whoops and the feigned pulsing cries of Canada geese. Dogs' growls and sharp barks from the human mouth and tongue. One shout. Then a ball rose just as

clear as a morning sun rises clear in its stepping up from and aside of a stand of hickories.

The men lifted nettings everywhere and the nettings themselves were attached to the curved ends of long carved sticks. The white priests called it lacrosse.

This was the Great Running, when a team with the ball, its opponents in pursuit, worked its way toward the goal, which was so far away Mary had to squint to see. She complained. "I can't tell what they are doing way out there."

"Playing," her sister said.

"Way out there?"

"Yes."

"But I can hardly see them."

"Yes."

"*Yes?*"

"I've noticed something about you." Her sister turned and looked at her. "I have noticed that you think many things, and events belong to you. You sound now as if you think that the game is for you. But the crossing game is only partly for you and for your benefit."

When the men played back past her, she became aware of a tangle of bodies, of dripping gashes on arms, of the rackety sound of stick on stick and, once, of a bone jutting through skin at a monstrous angle. Though she had never witnessed a battle, she knew what she was seeing was of the very texture of assault.

She also became aware of the body of the Delaware, Sheninjee, and how he held his head erect on his tall frame, and how that head was always turning, the eyes always looking, as if he himself were responsible for the whole of the game. He needed to know every man's movement or potential movement at every minute. He needed to know where the ball was, where each player was, what the angle of an incline was, where an anthill might be; he needed to figure everything that might affect the ball's trajectory. Everything was his field.

I who had never especially anticipated nor plotted any field, I who had either simply rejoiced at events or despaired of them as givens, saw in the Delaware something that must be the very opposite of sentimentality and wondered what would happen should I try to add that man's way of knowing to my own.

"YOU," said Branch, "have long been a woman. It is time that you married."

Mary turned her head. "Married?"

"I have you seen you look at the Delaware."

"Which Delaware?" She looked at Slight-Wind, who was sitting unusually still.

"You know which Delaware. The Delaware Sheninjee."

Mary's eyes were still on Slight-Wind.

"He also has regarded you. He has asked to marry you according to our customs."

Mary was now staring imploringly at her younger sister. But Slight-Wind said nothing.

Then Branch told Two-Falling-Voices that she must do this thing, that she must marry.

Mary drew in a breath and began: "I know that Sheninjee is noble, but—"

But, marry him?

SHE WATCHED Sheninjee as he handed the mink skin to his chief, who gazed at it and handed it to her older sister, who slid the palm of her hand along the pelt and then passed the gleaming fur to Mary.

"An engagement gift of import," the chief said. He looked at Mary and raised his eyebrows encouragingly, waiting for a reply.

Mary looked at him.

"The mink," Sheninjee said, "is a creature who will remind us of something that passed between us."

But Mary responded and said that she knew the mink was rather something that was habitually handed over as a mere bride price.

And the prospective groom said in reply, "What is given over according to tradition may become more than it was. As two find that in the space that has sprung up between them, a third being rises."

The intended bride turned her head in the direction of a scraping sound that came from outside the hut.

"In time," Sheninjee said flatly, "in time there will be children."

Mary's head was still tilted toward the scraping sound, which increased in volume.

"I have no more to say." Sheninjee folded his arms and looked up at the ceiling. The group sat in silence until the older sister said that the marriage should be accomplished quickly.

Mary then turned back toward them and said that it appeared that she had no real choice in this.

"You have said it," the chief said. "That is partial truth. You could run away or kill yourself. Or refuse and have no such opportunity again."

"Let her leave if she wishes," Sheninjee said. "My first act as her husband would be to set her free. If she passed from our village, I would ask our people not to pursue her."

Marry him? Marry him and stay so as to reinforce her own bonds, her own captivity? Marry him and ask that he honor his promise and set her free?

I knew that I should not, must not, forget that I was a captive waiting to be redeemed. As it was written: "Turn

59

again our captivity, O Lord, as the streams in the south. They that sow in tears shall reap in joy. He that goeth forth and weepeth, bearing precious seed, shall doubtless come again with rejoicing, bringing his sheaves with him."

I had never seen streams "turn again," reverse themselves. Were there certain streams in Israel, in the south of Israel, that turned back upon themselves with plashing and only slight flailings of fish? Was the Bible meant for Israel and not for me? Perhaps not for America, where there were renegades and traders and drinkers of rum and dissenters and people of vast ambitions. Father's body had been tense with this ambition.

But I myself was part of America, I in fact had been born at sea on the way here. They bore me as a secret seed to Penn's land, where seeds could fall and get lost. Where vast streams were too large to run backward. Did my parents know what they had done?

Or perhaps the Psalmist wrote "streams," but meant the turning back on itself of the Red Sea. I had often walked through the Red Sea as I lay under my quilt at night.

First, I saw Moses. "And Moses stretched out his hand over the sea; and the Lord caused the sea to go back by a strong east wind all that night, and made the sea dry land, and the waters were divided."

Then I started to cross with the children of Israel. "And the children of Israel went into the midst of the sea upon the dry ground: and the waters were a wall unto them on their right hand, and on their left."

The waves were as tall as the roof of our barn and looked to come crashing down on me, on all of us, but instead the threatening curves and curls at the top were arrested. They bent back on themselves and finally appeared as grooves, as thick crescents which looked like the sculpted wings of an angel in a drawing I had seen.

No drop of the Red Sea had dampened my clothing as I drew nearer to the glittering shore that meant freedom from Pharaoh. We were crossing over from bondage.

But there were no Pharaohs in America, only the Seneca and these Delaware, one of whom was actually courting her, if you could call it that. And no Red Sea.

And no one, not one of her family, was smiling now, nor would anyone smile an earthly smile again. Not one was reaping in joy. Not one would walk out of a field, would ever walk toward her with a flaring sheaf of wheat balanced on his shoulder and say, "Mary."

OR "LITTLE Sister."
 Or "Miss Mischief."
 "Our good girl."
 "Our pretty one."

Or from behind the coarse curtain one fragrant night: "Doubtless our Miss Mary is very intelligent, Jane."

A SIMPLE hymn was sung at the marriage of Mary, born at sea on the ship *Mary William,* and the Delaware Sheninjee, born in a birthing hut on the banks of the Susquehanna. The Seneca restrained their joy at the wedding ceremonies, out of uncertainty for themselves and out of tact of heart for the bride.

THEY lay on their backs on the pallet draped with skins, and Sheninjee said, "You are afraid."

The bride did not answer.

"You are sad. I know I am not white, but you are now truly one of our race, standing in the place of a brave family member." He paused.

Mary answered and said that he seemed to be saying that she should not be timid on the wedding pallet because her Seneca brother before her was a brave man. She asked Sheninjee if that was what he wanted her to think, if that was his strategy. She turned on her side and left him looking at her back, at her pale shoulders, her roan hair fanned out against her sleeveless brown undergarment.

Sheninjee turned from her.

The bride lay with her eyes open, waiting for what he would say next.

But the groom said nothing, nor did he move nor make another sound.

I soon found myself listening intently to make sure that he was breathing.

THE NEXT morning Mary laid her short-handled hoe on the ground and secured her hair with a thong so that it would not fall forward about her face. The corn was just above her ankles now, and she worked the weeds loose with one sharp edge of the hoe, being careful to bring up the weed-rootlets intact. And she made short chopping movements with the hoe, loosening the soil around the small stalks.

Then, bent over as she was, she saw a hoe blade flash behind her. She looked and then looked away: the hoe-er proved to be Sheninjee. To hide her surprise, she returned to her work.

She hoed. The hoe-er behind and to one side of her, working his way up the little hillock, was catching up with her.

What could he be thinking of? Men usually didn't hoe. I waited for him to stop, to give up. He was proud; he would not want some of the others, some of the men, some of the women, to see what he was doing.

━━━

BUT THE hoe-er did not give up, keeping just a little behind her. Mary twisted her lips to one side so that she would not smile, so that he would not see her smile.

But she knew the hoe-er's scanning eyes saw everything, so she finally turned to look straight at Sheninjee, who kept at his hoeing. He passed her as she stood staring.

She bent again and tried to catch up, all the while being thorough and exact in the weeding and loosening, not cheating, and after several minutes she was even with him and then she passed him. She knew he could pass her again easily, but he did not, and after a while she could not help herself and she looked around.

He had dropped way back and was hoeing slowly, in exaggerated fashion, as if he were a man caught in time trying to perfect a work.

And then she did something that struck her as odd: she laughed.

Without lifting his head, he picked up speed and caught up with her, never once looking at her. She turned back to her own quick hoeing.

The next time she looked up, he was gone.

When the night came, Sheninjee again found himself staring at Mary's back.

In the English he had furtively learned from Mary's younger sister, he said, "Good corn."

Silence.

And then the bride rolled over to face him. "What?" she said in Seneca.

"Good corn."

In Seneca she asked him, "What does that mean?"

To which the groom replied in English, "Good corn today. You laughed."

In English she said, "My sister has taught you some English."

"Good corn." He looked serious and proud.

Mary looked at him and after a few moments said in Seneca, "Good corn."

Then the groom smiled and with some caution and great lightness touched the bride's collarbone and said, "Mary." Then he took his finger away.

Mary looked at Sheninjee and then placed the tip of her own finger on his skin, on the indentation just above his collarbone and did not remove it and he allowed her.

In a half-light they awakened. She lay once more with her back to him.

Sheninjee said in English, "You have beauty."

The bride's eyes were open and she considered his statement. Then, though her body was still backed up to him, this time caught in his arms, she bumped him with a rocking motion and said in a slightly scoffing manner, "Good corn!"

———

He laughed a loud male laugh such that I imagined the eyes of my sisters in the nearby hut snapping open of a sudden, as do the eyes of disturbed turtles.

SEVERAL months later Sheninjee confessed that he himself had fears before his wedding night. Some of his friends had told him that white women were oddly shaped inside and had edges there that could hurt men in the act of love. The edges or borders of that secret place were sharp, sharp as raccoons' teeth.

SIX MONTHS later, while her husband was away trading furs for them and for their people, she dreamt that the child she was now carrying spoke and reproached her.

"Mother," it said, "what had I in some previous state done to you that you should have conceived me? Do you intend to wreak vengeance on me? For you have set me on a lonely course, a dark paddler in dark rushes. I am formed nevermore to live as a simple woman among her people. Instead I must be all eyes, nothing but ears, all ways conscious.

"Why did you allow my father to enter you? Answer me. Why did you allow him? You allowed my father, you allowed a man whose race tore you from your young womanhood and from your valley, whose race held the dripping scalping knife above your mother's head, your own father's head, the heads of your brothers and sisters—"

BRANCH walked up behind Mary, who sat awkwardly cross-legged at the river's edge washing undergarments, pounding and turning them. "I saw you notice the scalps hanging over there and now you look away: you turn from them."

Mary did not respond. Beyond her, an empty canoe wobbled in the water, tied up at the village's lowest docking point. On a pole in the canoe were strung two scalps. She had turned her back on the sight.

Between the two women there was silence until the older sister said, "You are not being your white parents' daughter in this."

Mary flinched and then turned at the mention of a subject which, along with her English, she had thought taboo.

My white parents?

69

SINCE her capture she had no forum and little voice for such a subject. Her childhood lay as if shut up before its time in a stoppered, milk-white vessel. Indeed she had come all unawares to prefer this separate, painful, but pure containment.

Now Branch's uttering "white parents" started something running, as a fine, dark line seems to rise of itself and course through thin porcelain.

"Like most whites in the lands across the waters," her sister said, "I am sure that they had certain wounds to the spirit. But unlike many whites, they had courage."

Mary's eyes were on her sister's face.

"And," her sister continued, "they decided their own path, a new path that might in the end bring comfort and healing. But their daughter is more timid. She cannot decide. She could leave us now if she truly wished to do so. But all she does is hide from her wounds, and the maggots fill them and they spread; they spread until her flesh is more used-up ulcer than flesh."

Mary turned away again.

"What is it," her sister said deliberately, "what is it, the English word for scalp?"

Mary did not believe she had heard her sister's Seneca correctly.

Branch said once more, "What is it? Tell me the English word for scalp." When there was no response she walked off.

Mary watched her go and then looked in the direction of the canoe. After a while she rose and went after

her sister, with the intent of answering her, of wounding the eldest Seneca sister with English, with the original language of Two-Falling-Voices.

This was how I came to say "scalp" in English to my Seneca sister in the heart of an Ohio village.

"WHAT?" her sister said at hearing a word.

"Scalp."

"What are you saying?"

In reply, Mary wound a strand of her own hair around and around her hand. Then she jerked that length of hair suddenly and violently upward so that she winced at her own action. "Scalped. Scalp," she said.

And then she jerked the strand of hair upward once again and the gesture was at once steely, accusatory, and full of acknowledgment.

SHE HAD lain for two days in the birthing hut before her daughter was born. Just hours before the child thrust itself out of her, she had struggled against being pinned to the pallet by something she could not control and had thought of hurling herself up and out the door and through the woods. She wondered if other, violent motions could distract, could oppose and forestall the painful thickenings and shortenings of her muscles.

Scowl-Face pushed into the hut. The white woman looked featureless to him, like the underbelly a turning fish might present. Her infant looked white, too, and strange, monstrous. He pitied the Delaware Sheninjee, having to explain this offal to other warriors.

Since the child had looked sickly to the sisters—was the infant really ill, they thought, or was it that she had been cast this pale, being part white?—he had been summoned. But he had stopped to pull on his wide ochre mask and position it.

Sniffing in the direction of the afterbirth, he spotted

it in the corner in a pot. It would make a rich pudding for his dog.

As he bent to examine the child, the white woman, leading with her hips and with her infant in her arms, moved reflexively away from him across the pallet as if she were hiding something.

I had wanted Weeping-Face to attend me. Why had they sent Scowl-Face instead? I wanted Weeping-Face.

BUT HE persisted, his fingers probing in the infant's wrapping. Suddenly he thrust his chin to one side and tilted his head as if to see better, his eyes slanting down toward the child. And then he sprang back.

"Dead," he said. He was disgusted. The new mother and her two so-called sisters jerked when they heard these words.

They had called him to perform against, to inveigh against, the evil spirits of an already dead infant. He turned and pushed out of the hut in a huff.

My infant's fingers began to uncurl, to go the color of sky at the tips, to grow cool to the touch. I did not want to sur-

render the little body of my daughter. Somehow I would keep it with me so that I could touch it, its eyelashes, its toenails, the stub where the cord had been, the milkweed texture of the hair. The child had the sensuous, perfectly fitted curves of Sheninjee's lips. I must keep this little body close for all time.

AT DAWN, when Mary's fever began to lessen a little so that she slept, her eldest sister lifted the tiny dead one from the arms of its mother and walked straight out the door with it.

As if in a dream I saw the shape of my husband push into the hut where I lay and then I heard him speak, asking my sisters why his wife was still in this miserable place; the answer came from my elder sister in the patronizing tone that often infuriated Sheninjee: according to custom, the ill one must be kept in the isolating-house. Besides, she told him, you were absent, late in coming.

SHENINJEE took care that both his feet were flat on the ground and that his weight was evenly distributed. In the time that this took he was able to compose him-

self, so that he said steadily, "The child came early. As you know. And," he said, "I think that the custom in this case offends against the Great Spirit." Then he bent to touch his wife.

She was asleep and listening to her dead child: "Now am I justified, now am I released. I will never have to suffer the scourge of your stained earth. Mother, I will see you one day. Rend your heart, wipe your eyes, put off grieving, and keep this simple resolve: that my father should never enter your body again."

I was thin with fever and always chilled, and Sheninjee kept me warm with his body in the cool of the night. He mashed my food and repeatedly gave me to drink. He studied me as he might have studied a book were he able to read. He made me ill at ease, as if he feared that I might die before my time.

And later, when I could walk again, we moved through the village, and when we sat in the sun to rest, a thin dog licked salt from my ankles.

When we sat to fish, I watched my husband cut into the speckled trout he had separated from the creek; with one quick turn of the wrist he could slit the fish and free and lift out the blood-black line which lay along the fish-spine.

Who would wish for some other world?

Then I laughed at the thought that I, of all women, had just had. I laughed so loud and so heartily that my husband jumped back a little from me just as he would jump back if one of his trout opened its mouth, spit out a coin, and began to speak to him.

HER STRENGTH had clearly returned by the time the corn began to ripen, and one day when they were out walking her husband turned from studying the horizon to find that his wife had disappeared into the cornfield.

"Two? Where are you?"

But there was no answer.

"Mary!" He called her Mary when he was worried.

From a little distance, he heard her: "Sheninjee?"

"What are you doing?"

"Come and see."

He found her in the thickest part of the cornfield: she had taken off her outer garments and placed them on the ground. Now she wore only her loose brown undergarment. She held her arms up toward the warmth of the sun; she was stretching. And then she lowered her arms slightly, turned, and held them out to him.

When he stepped over to her, she held up her index finger and placed it on the bridge of his nose. She drew a light line downward until she reached his lips. There her finger rested as if to hush him. Sheninjee breathed,

finally, and his lips parted. Then she lowered her finger and brought her own lips close to his. He raised his eyebrows.

"I feel strong," she said.

"Are you certain?"

In answer, she slipped one strap of her undergarment off her shoulder and let it hang loosely against her arm.

Close against him, she traced the curves of his chest with her slim fingers. She traced slowly, in ever-descending arcs.

WHEN the seasonal afternoon light the color of corn silk lay on the hills, Mary and her husband often picked up gouged lacrosse sticks and moved a ball back and forth between them. Later they walked together, and sometimes Sheninjee withdrew somewhat from her to scan both the far landscape and the clumps of trees that lay afield near the creek.

She had lately learned to turn from excessive studying of her husband's face to study the trees, the underbrush, and the sky.

In this way, my world opened and I began to comprehend all lineaments, even my husband's, better.

S HE S AW, one late afternoon, a red-tailed hawk before Sheninjee did, and she laid her hands, fingers splaying, flat on her rounded abdomen and told the new child in her womb that a hawk was present and that its tail had the coloring of chokecherries, that it could properly be called the chokecherry hawk, that the vibrance of red and the perils of choking might be a suitable name for a hawk.

She wanted now always to live in these fields or fields like them where living creatures breathed, moved, changed, died; but where curves, hollows, projections thick as bluffs or slender as tree-stalks, remained largely stable.

A field of spaces, she thought, beset by form, color, and texture; spaces beset by odd or ecstatic or violent movements: scuttlings, fallings, startled flights, crawlings, hesitations. A field where the foreignness of revisitings was most appreciated in a familiar setting.

A thought seized her: she wanted to own land.

I flushed and glanced at my husband. He would be incredulous to hear of this, he would frown. Own land? Could any idea ever sound as foreign as this idea to this man?

BUT LAND and the desire for land could be a loose strainer, a context, a catchment not least of all for the naming they did, for the tongues they spoke, both English and Seneca, despite their differences, despite their partings of speech.

ONE DAY a month or so later, Sheninjee said to his wife that he guessed she was thinking about a name for their child. Mary made no reply.

"Is that not so?" He looked into her face.

"Is what not so?"

"Have you been thinking about a name for our child?"

"Yes. A little."

"Well?"

"Well—"

I had thought that if we named this child, then should it die after birth as our first child did, we would feel even worse. We would not just lose a child; we would lose a person, someone to whom we had given a name and who therefore had clearer features.

When God brought the animals to Adam and Eve to name, did they then not love the beasts the more? When Eve called the lamb "lamb"—for I was certain it was Eve who named the lamb—did she not love the creature almost desperately afterward? It was more different from the other animals after she named it than it had been before.

SHENINJEE regarded his wife. "What is the matter?"

"I am not certain about a name."

"I have thought of some names for you to consider. If the child is a boy we could call him 'White Fox.' "

"White—?" She recoiled.

"Or," he continued, "if a girl, 'Red Snow.' "

Mary looked at him sidewise, in disbelief.

"But," he said, leaning back, for he was enjoying himself, "there may be better names. For a girl—perhaps," and he spoke a name that was inaudible.

"What?"

He spoke the name in the same hushed tone, but this time he leaned forward so that she heard it. "Jane."

"What?"

"Jane. After your mother. Are you losing your powers of hearing?"

BUT SHE gave birth to a boy, not a girl. Sheninjee asked if she had considered naming him Thomas.

Mary cringed. All she said was, "When we were captured, my father acted like a dead man."

"He did not act nobly, then," Sheninjee said. "But perhaps he really was a dead man. You were seeing his ghost walking, the flesh still draped about it."

I thought Sheninjee was right. In fact, I remembered thinking that the man who refused to speak to us or to comfort us right after we were taken was in no way like my father. "If our child were to be called Thomas," I said to my husband, "we could think of him as named for my real father and not for that man who, after my capture, only looked like my father."

Then I waited for Sheninjee's response, which was slow in coming. When he finally spoke, he said, "What I think makes no difference. It is the Seneca mother, as you know, who names her child. I," he continued, "have nothing to do with it."

Would my son die after two days even as my daughter had died?

I would not be parted from him; even while I relieved myself I would hold him and if he was awake gaze at his eyes, will him to focus on me, and I would concentrate on him, as if such methods would keep him alive.

His eyelids kept fluttering, his eyes kept closing as if they were weighted. In spite of this, as the Messiah had done in the Scriptures, he appeared to wax and grow strong; though, I thought, there could be something inside his little body I could not see, some evil in his intestines, something malformed under his small skull.

"I AM going to take our Thomas and walk about with him," Sheninjee said one day. "I am going to show him off to the men and I am going to show the men to him."

She protested.

Sheninjee looked coolly at her. "If you were ready to do so, if you were ready to see your fear as fear, you would look closely at Thomas and see that he is perfectly healthy."

In later days, I would look at my baby's maleness and feel a sort of peculiar pride. How strange, how delightful that I, a woman, had grown a male creature inside me. With some shyness, I told my husband my thought.

JUST a few months after Thomas was born, the spring season began.

The reds and oranges of wild columbine hung all about in May; for the first time she noticed how yellow their stamens were. She would hold Thomas close to the blooms. "See? Can you see that? Can you see those colors?"

A little later when the touch-me-nots appeared, she imagined how her baby, when he grew older, would play with them.

He would be frightened, perhaps, at first to see what happened when he touched those blond flowers with the red-brown splotches on them: I called them "scatters," for when a finger is put to them they explode, spewing their tiny seeds everywhere. I was sure when Thomas got over his fright he would wait every summer until the flowers became mature enough to do their little tricks.

"They're not doing it yet. When will they do it, Mother? They're not doing it."

"Be patient," I would say. "They're not ready to do it."

THINGS seemed more various and intricate than she had remembered. The whitish nubs of leaves which had begun to shoot from the catfoot stems in later summer were fragrant from the first. And when the catfoot itself appeared, she held it to her baby's nose, being careful not to let any of its bristles touch him.

I thought then that it was because of Thomas that the earth was as if new.

WHEN the days were hot, she could smell animal dung on a path minutes before she saw it. In the warm nights her body was damp from its being so close to Sheninjee, and her hair, long as it was, curled into tendrils as if it were new fern foliage.

She welcomed the smell of apple skins and the texture of the black walnuts. As the days grew a little shorter and the evenings cooler, she felt the contrast to the skin

of passing from out-of-doors to indoors where the smoky fire twisted and burned.

After a day of scraping corn kernels from cobs, she would wade into a shallow place of the Ohio with her son, her arm around his waist with him facing away from her. Then she would swirl him back and forth in arcs in the cool water, and he would kick his feet and rub his creased ankles together as she had seen blue flies do, as if he had something annoyingly sticky on them.

When the corn was dry, she pounded it in preparation for making samp. When she was new at pounding her arms burned with the effort, but then she grew used to it and welcomed its very difficulty; the repeated downstrokes that resulted in the sundering of kernels reminded her of how she used to split wood, of how much power she felt, of how she fell into a rhythm, of how spent yet peaceful she felt afterward.

She loved her block and pestle and her other utensils as well: two large clay kettles and a smaller one, of brass; two knives; two vessels of heavy bark; a deer-jaw scraper. She kept them together and free of dirt and of the droppings of mice.

The cooking of the cakes gave her pride: swirling water into the meal, mixing and shaping, then placing them in the baking pit, covering them with broad oak leaves, then with warm ashes, and finally with hot coals.

―――――

When my hands were small, I patted the meal mixture into what must have been very uneven cakes, for Mother would follow me and reshape them, which hurt my feelings. My favorite part was when, in the winter, we put two cakes on a broad hoe blade which Father had brought in; then we held it over the fire in our hearth. As soon as the thinnest edge of the blade began to glow, I would smell the corn-mush fragrance and my hunger would be sharp and Father would look at me and say, "No one is hungry in this house, are they?"

"I'm hungry."

"No."

"Yes, Father! I am hungry."

"No."

"I am!"

"Then," he would say, "you shall have your hominy pominy!"

"For I shall have my hominy pominy."

And Matthew said, "For we shall have our pie!"

"And," Robert called out, "we shall have our hominy pominy pie."

Betsey would say, "It's not a pie."

But I would stop my reveries when feelings rose inside of me: our father had abandoned us when we most needed

him. And then I had a thought that was terrible. At Fort Duquesne, I had acted like Father. What he had done to me, I had done to little Daniel.

WHEN the first snow came, when she stepped outside to find patches of white skimming the earth, a sudden nausea gripped her.

She did not speak of her memories of the snow, but some days she served cakes of corn which were salted with the water of tears.

"I THINK that time," Sheninjee observed weeks later, "will make your cakes less salty."

In TWO years' time Mary and her husband left the Ohio River lands to visit her Seneca sisters, who had gone to the Genesee Valley to live with the rest of the family. And when Sheninjee helped her step into their fur-laden canoe, she had Thomas on her back.

Now they were leaving Ohio and her child was slung high enough so that he could see out just above the line of her shoulders. Always he was swiveling his head, like an owlet, to look at every living thing.

They paused at a creek mouth at the outlet of Sandusky Lake where a trading house sat back in the trees. Nothing stirred.

Sheninjee studied the scene and said, "The English traders are absent. No canoes." He frowned. "They were supposed to be here. Perhaps they are sleeping somewhere downriver—drunk on rum as usual."

Then they lifted their paddles and moved forward.

As the canoe began its turn around a bend of the narrowing river, Sheninjee saw three objects floating. He focused, calculated their dimensions and the rate of movement on the current, and was sure almost at

once that they were bodies. He turned to wave Mary off the sight of this and then remembered the change in her and stayed his hand. Instead, he spoke. "The traders."

What she saw, then, was a grotesque trio, an exercise in varieties of torture unto death. One man was fully clothed save for his boots but had no nose; the second was nude and had an arrow jammed through his penis; the other was half dressed and missing his feet.

The bodies drifted past their canoe. Sheninjee, who had pulled his paddle from the water, sat motionless, and in her husband she saw an unusual few moments' indecision before he spoke. "We must not continue just now. The whites we will meet up ahead may think some of us did this."

Us?

So they turned back.

They brought the canoe aground in shallow water at a low bank in front of the trading house. Even as Sheninjee secured the canoe he noticed that the house's door was open, and he again became motionless—this time for just a few seconds. Lifting a hand to warn Mary,

he made his way alone up the short bank and across a length of ground to the trading house. He walked through the open door and paused until his eyes adjusted to the dim light within.

Here were three Shawnee and a youth, a white man who was tied to a chair, his face twisted in pain or in grief. But it was pain, for then Sheninjee heard him whimper and saw that the ears of his head had been carefully sliced so that they looked stringy.

The Shawnee, inebriated, regarded Sheninjee, who returned their stares. The white man seemed to fall into a semiconscious state; he slumped against the ties securing him to the crude chair.

Sheninjee said, "Who is this man?"

The tallest Shawnee held his head to one side as if his neck were stiff. Impressed with Sheninjee's bearing, he narrowed his eyes in an exaggerated way and said, "This one? This—stinking white? He was with the traders when we met them. We brought him here through the woods."

Sheninjee studied them. "This," the Shawnee continued, "is a stinking white, not a man. This is a pig." He lifted his knife and made a swift diagonal cut across the shreds of the prisoner's ear. The young man screamed.

Sheninjee was careful not to take a step forward. "What has he done?"

"He was born a white!"

Then the tall spokesman and the other two Shawnee started squinting and blinking: a woman with a baby in her arms had stepped into the cabin.

And the woman said in a low voice, "Untie him."

"Mary," Sheninjee said in an even lower voice, "better to ask them, not order them."

She took a few steps forward and appraised the young white. She looked from Shawnee to Shawnee. "Is this action for justice's sake?"

The captors looked as if they could make out neither her physical presence nor her question.

"Will your chief be proud of his warriors when this story is told all across these lands?"

The shortest of the three Shawnee looked at the tallest.

"Please," she said, "let him go."

Exchanging glances, the men set their faces against her.

Her son began to cry. She handed Thomas to Sheninjee, but the child continued to cry and the cries became louder and angrier until they had turned to wails so disconcerting that the Shawnee involuntarily took steps backward.

She advanced as they retreated and raised her voice above her son's crying. "I beg you."

Thomas screamed and the Shawnee, to a man, winced. As if to take some action to end the overwhelming sound, the tallest Shawnee lurched forward and with drunken bravado sawed the binding thongs

away from the young white's wrists. "There. You are free." Then he looked at Mary. "Ha." He paused and then he laughed again. "You may leave," he said to the white man.

Now the shortest Shawnee was also laughing. He tottered over to the prisoner and said, "Use your ears for boat sails!" Then he held his sides, bent over suddenly, and vomited.

"Get up," Mary said to the white, who looked stupidly at her. "You must get up on your own and leave without our help. The Shawnee would be angered if we assisted you. They would see it as losing face."

She tried to hold the young man's clouded gaze and even as she did so, she despaired for him. But he moved his lower jaw to one side in a kind of spasm, in a concentrating contortion she recognized from having seen it on Sheninjee's face in the act of love. And then the youth was up out of the chair and hurling himself like a demoniac across the room, drops of blood marking his path out of the door.

The Shawnee stared in disbelief. Mary turned from them; her husband handed her the child, who made no sound as his mother walked out of the dead traders' house.

[III]

The Genesee Valley

1763-1833

AT GENESEE, her Seneca sisters came to her, flanking the Seneca mother she had never met. The mother carried with her a shawl of blues and burgundies and dark greens, and in one effortless gesture she lifted a corner of it, shook it out, and draped it around Mary's shoulders where flakes of snow had begun to accumulate.

In the days that followed I watched the mother, who often spoke to me and who had a habit of touching me lightly on the hand when the talk was over and we were about to part. How to think of this woman? As my sisters' mother? As The Mother? As an adopted mother? As my mother?

I thought of the mother at that time with the English words which lay close to the meaning of her Seneca name: Bending Tree.

TREE WAS lean and had face bones that rose to meet the outer edges of her eyes. Men everywhere stared at her, and she met their stares with a gaze that was as formidable as her bearing. Ultimately, the men looked away.

SHENINJEE in a gesture reminiscent of a marriage ceremony handed his wife over to the Seneca town, to Tree, to her sisters, to a river and valley thick with people, and then he withdrew from Genesee for several months to trade pelts. He promised Mary that he would return in the spring.

And he added, "Whites come and go here. English and Seneca are both freely spoken. While I am away, don't gaze too much at the white men."

And she replied and said that he himself had not looked enough, that had he been discerning he would have seen that it was the New York Seneca men who were, both in limb and in visage, the handsome ones.

AFTER Sheninjee had been gone for two weeks, Tree noticed that Mary's spirits were downcast and so she said to her, "If you like, we can cook together."

She taught Mary how to find the wild asparagus, yellowdock, poke, and milkweed and how to use them in

cooking. The puffball mushroom, she said, made good sauce or soup; it also tasted better with a little salt and oil on it, and she cautioned about the difference in taste and texture between sunflower oil and bear-grease oil.

The two women bent over the remains of a hearth-fire and the older showed the younger how to bake apples in it and how to catch the apple drippings so they would not be wasted. She demonstrated how to make an elderberry syrup to give to people who had fevers and a Juneberry tea as a blood-loss remedy for women.

"You know so much," Mary said to Tree.

"My mother and others taught me. Food is a gift I give to others." And she told Mary that since food was usually eaten quickly by those who were hungry, some grew tired of making it. But those tired ones must have tired eyesight as well, she said.

Could they not see that eating bear-grease oil made a person's eyes shine? That well-cooked beans stirred up the bowels and exercised them? That strawberries and blueberries brought color to one's family's cheeks? And she said she thought that meat made people strong and that food in general seemed to lift people's burdens so that their spirits could grow.

Then she said, "Did you enjoy the foods you ate when you were with your white family?"

Mary shook her head, and Tree could not tell whether this motion was up and down or from side to side.

MARY and Slight-Wind watched a river of execution objects wind past them. First, the two white prisoners themselves, taken in the recent French and Indian ambush near Fort Niagara; they were bound and stumbling, being pushed forward. Then a great cheer went up, for captured oxen followed, the first oxen ever brought to the Genesee flats. And later, robes, fruits, vessels of drink, beads, musical instruments, and firewood were borne along, specially prepared for the ritual burning.

Mary had seen the powerful look one of the Seneca captors had given her sister, and so she nudged her. "That warrior is attracted to you."

Slight-Wind said only, "I want to go."

"Go?"

"To the frolic, to the festivities. Come with me."

"To see them die? Well, you can go."

"No, come with me," her sister said. "You've told me you could look on anything now. Mother will take care of Thomas. Aren't you curious?"

"A little. A little curious."

———

Slight-Wind said, "We want to attend the ritual." She and Mary stood close to each other.

Tree looked at the two women for a long time and then said that she advised them not to go. She asked her blood daughter what her motive was for wanting to stand before the warriors' fires.

"You have already lost one brother to the whites in warfare. Have you forgotten? But I, his mother, remember. You could lose another brother to either the whites or another tribe: that suffering and death would be fresh in your mind, I think, for many years. And you would remember with rue how gaily you attended these prisoners' executions." She continued: "How can you think of taking your sister to the spot which will become charred, a spreading stain?"

But Mary answered and said that she had indeed declared herself curious, that she had told Slight-Wind that she half wanted to go.

Tree turned to her adopted daughter then. "And you, too, have lost family, have you not?"

Mary flushed. "Yes. Quite long ago."

Tree was determined. "How long ago?"

Mary did not or could not answer.

"How long ago? Do you not remember?" Then she asked if Two-Falling-Voices really wanted to hear the screams of the whites, and said that this execution could well open wounds best left closed, that to be a witness to such an event would be a torture to the self, that putting

the knife anew to a scar for the sake of curiosity was a violence to the self.

And she said that their own work needed their attention. Then she spoke her final sentence: "Leave it to the warriors to perform their fading, gritty customs."

The men were burnt on a cool November day, on the north side of Fall-brook.

All I could see from the knoll to which I had gone was a pillar of smoke.

IN THE planting season mornings, Mary would take up her place next to Tree. The older woman noticed that her adopted daughter worked in silence but also often lifted her head to look in the direction of a wooded area which swept in a kind of S-curve down a hill.

On an evening when Mary and Tree walked out together, the younger woman spoke.

"My husband is dead."

Tree stopped walking, but Mary continued, and Tree then sprang forward and re-established herself at her daughter's side.

"He said he would come to us before the planting season. So since he has not, he is dead."

From that day on, when she lay full-length on her pallet at night, she felt the space where Sheninjee had been as a weight which pressed against her with a sharp-edged, rangy force.

TWO MONTHS after that walk with her adopted mother, Mary received word that her husband had been taken ill at Wiishto and had died there. The Seneca who told her the news looked steadily at her.

"Yes?" she said.

What else did this woman want to know? The man had come through a soaking rain and was tired and uncomfortable. He had a cough.

"Yes? And what was his illness?"

"I do not know."

She saw that he had several gray hairs. She tilted her head a little to one side, moved her feet slightly as if to balance and position herself, and then appeared to settle into a gaze.

He wanted to end this interrogation. "I think his illness was, ah . . . a fever," he said.

"A fever." She saw that the man had a scar just forward of his ear.

"Yes."

"And what kind of a fever?" The man had large eyes, and just weeks ago with these eyes he had seen Sheninjee alive.

"I do not know," he said, and then coughed.

She hated the sound of his cough. She hated his scar. She hated the coarseness of his gray hairs, she hated it that rain had streamed down his chest, she hated his odor, she hated the shape of his nose, she hated it that he was breathing.

How dared he? How dared he be in that place where my husband was, and not keep my husband from dying?

WEEKS later, she stood in the soft shadows of the cornstalks. The privacy was the same. If she took off her outer garment, would Sheninjee prove himself not dead, would his large body make the ears of corn scrape and scratch against each other as he approached? He could not resist coming to her, he must come to her in the corn if she stretched her arms out to the sun and then out to him. He would say her name; one brown finger would trace the path of her left collarbone.

She would touch his face, his nose; she would do what he loved. She herself would slide her strap off her shoulder.

In the cornfield, in her thin undergarment, she raised her arms and held them out in front of her. Then she lowered them.

NOW THAT her husband was dead, the dark thought of leaving the Seneca again occurred to her, grasped her one day when she was in her hut and sweating in the hottest summer she had ever known.

I could go back now. This is the time.

The heat contributed to my longing to be in another place. But in what place, I bethought myself, amongst whites or anywhere else, would I escape the moist air that oppressed me such that I felt faint all the time? The whites, like the Seneca, could do nothing about the heat. I had heard someone say that the waxy, mask-like makeup that wealthy white women wore tended to melt in the summer daytime heat as well as before a fire in winter.

IF IT had not been for Thomas she would have wished for death again. "It is better for me to die than to live," Jonah had said when the gourd withered and he sat bareheaded under the hot sun. He had been very angry.

At that time she would have welcomed being swallowed up, as Jonah had earlier been swallowed up by a fish. "And Jonah was in the belly of the fish three days and three nights."

That was what she wanted: nothing less than being swallowed up would do. In the belly of the fish the heat would cease to bother her.

Inside the great fish it would be cool, if damp and somewhat putrid. What had Jonah done inside there

for three days and three nights? She thought perhaps Thomas would ask this question when he got older and he heard Jonah's tale. She began to think about how she would answer.

She would say, "First of all, Jonah prepared a prayer of thanksgiving. For he had been saved from the sea into which the sailors had thrown him. For he had nearly drowned. For the water had encompassed him and he had kept swallowing it and coughing it up and breathing it in again so that his throat and stomach had started to fill with minnows and bits of green seaweed. And he was still retching while he composed his prayer.

"And the Good Spirit, the Beautiful One, saw him preparing his prayer and said, 'Jonah, stop that. First vomit up and spit out all of those minnows and fragments of seaweed and calm yourself. And then prepare your prayer. How can you think in a fitting manner while you are suffering this vomiting?' And Jonah did what he was told and then he made his prayer and spoke it to the Lord.

"Afterward he looked about him to see what he could do. Then he made the best of it and found the softest spot in the fish's stomach and put his coat down on it and used it for sleeping and for a watching post, a lookout, to see what marvels would be passing through before his eyes and to see what he could catch for his dinner, for he was hungry after all the vomiting.

" 'Now,' said the Good Spirit, 'you are finally doing something intelligent. Feeding yourself.' "

Then Mary thought of how she might spread Jonah's story out for Thomas over days and days. In this way, she distracted herself from the heat for a while.

It was true that I could try to leave the Seneca now and try to find someplace like Joppa, as Jonah had done. I glanced at the sleeping Thomas.

But he had the darkest eyes and although his hair was fair, his skin was of a brown color. Would white children play with him? Would they laugh at him? Would the English I could teach him be good enough? Most likely he would be forever fatherless there, in that white country.

"THE KING of England—"

She did not hear the rest of Tree's sentence for this unusual name on her adopted mother's lips.

The King of England, I thought, could he see Tree, would fall in love with her at once; but Tree, could she see the King of England, would study him.

"I DID not quite understand what you said."

"The King of England has offered a bounty to those who would bring in white prisoners."

Mary suddenly understood why the white trader who was visiting their village, the Dutchman John Van Sice, had kept trying to engage her in conversation, why he had pressed her to take walks with him. She half laughed and told Tree that she had thought Van Sice was interested in her for her being white and unusual-

looking but now she understood that it was because she was white and sellable.

"That man, Van Sice," Tree called him. "That man, Van Sice, has never pursued real beauty in his whole life and if he had he would have thought only of how to bed it and never of how it could change him forever." Then she paused for a moment.

"Are you tempted now," she continued, "to deliver yourself to him? Whites are to be taken to Fort Niagara to be redeemed. Then they are to be set at liberty."

Mary lifted her eyes from Tree's face and looked just above her mother's head.

And the next day Mary spoke. "I do not want to be redeemed." She paused and spoke again: "For now."

In this manner Tree was given to understand that her daughter, steady as she might be, would always inspire anxiety in those who sought to know, who sought to claim Mary as one whose thoughts and actions were mere traits.

ON THE margin of a pond Mary and her son were still as they watched a small heron catch a lizard, and as they gazed, Black Coals, one of Mary's adopted brothers, stalked across a clearing and entered the family house. She did not see him arrive, but when he left again she saw him.

The lizard struggled in the heron's mouth and tried to wrap its exposed parts about the upper beak so as to tear itself free, but just as Branch appeared at Mary's side, the heron tipped its head back and forth, gained more leverage on the lizard, and swallowed the rear legs, the torso, and finally the head. Thomas jerked his own head back in astonishment at this.

Mary turned to her sister. "What is the matter with our brother? He did not stop to talk to us."

"He has come from the council. The old chief wishes to take you to Niagara and obtain the bounty. And—your brother has spoken out. He would rather see you dead."

"Our brother is upset."

"He is more than upset. He cried out in public that

if the chief should try to take you against your will, he himself, your brother, would kill you."

"He *is* very angry. Full of bluff and threats."

"He will, I am certain, try to kill you with his own hands." The look in Mary's eyes stopped Branch for a bare moment. "He will return before sunset to let me know the effect of his speech on the chief. You must go off to the thicket beyond our house and stay there until the moon is the only light. Then come quietly to the door of our house. If you are to be killed—" She broke off, considering. "If you are to be killed, I will bake a small cake and put it outside the door. If you find it there, take your son to the large creek and wait until you hear from me. If you see no cake, come inside. You must get up now and get a blanket for the night."

Mary made no move.

If I am to be killed . . .

"GET UP."

They regarded each other.

"Get up. Remember who you are. Remember the

113

story you told me about the young man you saved from the Shawnee? He got up. In all his misery he got up. Besides, you have a son. Get up."

WHEN she moved beyond the bushes and tangled vines she crouched down and reached out, and her hand disappeared in blackness because the moon's light did not extend to the porch boards. In the spacious dark, her fingers touched something grainy. It was the edge of a cake of corn.

And though Black Coals had not as yet touched me, the edge of the mealycake was a violence unto me; it rocked me back and stunned me to the soles of my feet.

HER SMALL son was curled up against her like a fist when she opened her eyes at the place called Samp's Creek. The first thing she saw was her brother's stern face. He was standing over them.

Then he smiled. "The old chief could not find you. He has given up and gone to Niagara."

After a minute Mary stood up and then stepped back from her brother. He pointed his finger at her as if he thought she was being inattentive.

"I said he has left. You are safe. What's the matter with you?"

"I am safe from the chief?"

"Yes."

"And from you?"

Her brother blinked. "From me?"

"You were going to kill me."

"Yes—"

"Without asking me what I thought about a redemption."

"Better death than being taken somewhere by force. You know that."

His sister stepped to one side, as if she thought she was standing between him and something he should see. Then she asked him to whom he was talking.

"To a Seneca."

"What is a Seneca, then?"

He turned impatiently away from her. But she followed his motion, his turning, and moved close in to him.

"No, face me, stand tall and tell me, what is a Seneca? All identical ears of corn? Feelings all alike? All equally brave? All equally bloody? All male? Let me look—" With a jerk she pulled up her skirt. "I will show you my maleness. And you show me the place in your

body where there resides some considered thought, some common sense."

Now her brother once more turned his back on her, but she would not be silenced, and she again walked around and faced him. "How can you be sure what I want or think?"

"I was wrong," he said. I only thought I was talking to a Seneca. Instead I've been talking to a white. You have not stood in the place of our dead brother after all. Inside yourself you stubbornly resist our ways."

"Whose ways? Yours? Your mother's? The old chief's? I am white—"

"That is clear."

"And I am Seneca. And I am a woman. What happened to the idea for which we are known here—that our men and women are good partners. Why does a woman rejoice when she finds it is the Seneca who have taken her prisoner? But wait until people hear that adopted brothers go around deciding on life and death for their sisters."

"I'm going. I'm going to leave you here talking to yourself."

"You loved my husband. You said you had never seen such a strong and wily ballplayer." She stopped to scoop her son up into her arms. "Now he is with the Good Spirit, active, with even more skill than he had on earth. But he is ashamed on account of you: a Delaware thought a Seneca would have more sense. How will you face him and explain this to him when you die?"

She handed her son to her brother so she could fold up the blanket, and the child stiffened, stuck its arms out at its sides, widened its eyes, and looked at him.

"My brother, let me make the few decisions in my power about my own life and death, about on what lands I will roam."

IN THE evenings at Genesee she sometimes walked with the warrior named Hiokatoo. Though his hair was gray, he made some of the younger people among them seem older than he himself was. He talked with Mary in a lively way and gestured as he did so. He loved especially to speak of his youthful athletic contests.

She began to see that she was infatuated with Hiokatoo. When he noted this, he pondered for some days. Then in conversation with Mary, he began to dwell less on his youth and more on the days of his manhood. His references to ferocious battles and personal bloody feats became more frequent.

Slight-Wind said to her mother, "Hiokatoo and his stories! He never used to boast this much. I tire of hearing him talk. I always liked him; now I walk off in a different direction when I see him coming. How can Two-Falling-Voices listen to all that? Does he think he will impress her this way?"

"Hiokatoo," Tree said, "knows what he is doing. 'Look at what I have done in the past,' he is saying.

'Will you,' he is asking your sister, 'be able to stand that in me?' "

One late spring, they married.

Hiokatoo had a temper. Passionate by nature, he told me about his ardors. Sheninjee by contrast had said little about his feelings, and the remoteness that often hung about my first husband had made him mysterious in a way that was attractive in my sight.

But Hiokatoo was expressive; he talked in an interesting, wise way with me; I learned things about the world from him.

HIOKATOO hated the telling of anything that was not true and looked with disdain at the sleights of hand of deceptive men. Of the widespread stories of feats of the great Onondaga warrior, Aharihon, there was one that Hiokatoo detested: Aharihon had pretended to adopt a young white man in place of his brother who had been killed in battle.

When all were feasting on the savories—hearts, haunch meat, back and rib meat—of four white dogs that Aharihon had himself generously provided for the

adoption feast, he suddenly announced that his new "brother" would not be an adoptee at all, but would on the morrow be roasted in the manner in which the dogs had been roasted that day. He meant that the roasting would be slow. This was accomplished according to his directive.

Hiokatoo, disgusted with this man's pretense, would when he heard the story try to contain himself until the teller finished. Then he would say, "Bah! I myself would have roasted Aharihon for such lying behavior. Starting with his feet."

My second husband was so handsome that people sometimes stared, but he was always and everywhere faithful to me—I never feared that his shadow would fall across the pallets of other women. He was virile. But he was different from Sheninjee, who in matters of love had been less preoccupied with enjoying his own potential.

BY HIOKATOO she had five children—Jane, Betsey, Polly, John, and Jesse. With Thomas, then, they were a family of eight.

———

My husband built us a house after Jane, Betsey, and Polly had been born and during that time when I was still carrying John. I told Hiokatoo I wished to live a family unto ourselves instead of sharing the hut with others, and he agreed. It was the length and width of about four men and had a shingled roof and at my request a tall door and a stoop. We built a kind of stone chimney over where the fires would burn so that our dwelling would be less smoky. The lack of a real table or proper bedstead did nothing to diminish my joy.

When the house, or hut, was finished I first moved all our possessions in and arranged them. Then, full of a variety of enthusiasms, I stopped to do the heel-and-toe dance of our people.

Truth to tell, in the succeeding years I was almost completely content. I had the comfort of having a husband again. I had many friends and we rose in the mornings eager to gather up our children, meet, and work together. I cannot remember a day when I was lonely for want of company. We gathered fuel, we harvested corn, we made samp, we dressed game, we spoke of our husbands. The work proceeded in a leisurely fashion, and I never felt hurried and overburdened as I remembered my white mother often was.

The word "yoke" came to me and then, "Come unto me all ye that labor and are heavy-laden and I will give you rest. . . . For my yoke is easy, and my burden is light." For me this saying of the Lord's was fulfilled in my life among the Seneca.

The Lord. What a strange name for Jesus. It must have been the British who titled him "Lord" in the English Bible.

Since I had no one to talk to of Jesus, he had begun to fade in my mind like the image of my father's face. What of Jesus?

His name was mentioned here and there by my people, but mostly in boasting stories of how this Seneca or that had run off the Christian missionaries. Jesus himself was not an object of scorn, but the Jesuits were another matter.

For my part, I remembered how Jesus in the Scriptures had always directed attention to his Father in heaven and away from himself. He had said not to call him good; he had said that only God was good and that his Father was greater than he was.

I thought then that he knew he was part of the Good Spirit and that he had things to say to the Hebrews and to the Romans, and that he took care of people who suffered and that these were the important things. Share the spirit of his ways, I told myself, and the spirit of the ways of others who are like him—persons like Tree. Then leave the rest to the Good Spirit. Jesus, I thought, would understand this.

But my dreams troubled me: from time to time I saw my white mother. She always approached me and stared at Hiokatoo and at my garb. When she took in what had become of me, that I loved the Good Spirit but was not a Christian, she would cover her mouth with her hand.

"Mother," I said to her. "Mother."

And in the dreams I thought of hiding my children from her. Instead I said to her, "Mother. I have children. Come and see my children."

However, she would turn away and would not look upon them and would say to no one in particular, "This

woman who was my daughter is but a shade of what she was. These children, along with their mother, neither read nor write. My white grandchildren, had I had them, would have been able to read and write."

With that, she would walk directly away, and as she walked she would say, as if addressing the sky or the wind, "Remember me." I believe she said this in order to prompt me to alter my life according to her wishes.

T

A straight line at the top.

Then a straight line underneath that rose up in the middle to meet the first line.

T

T

T

She inscribed a *T* in the reddish wet earth and tilted her head. *T* was for tooth and Tree and turtle and timbrel and table and Thomas her son, and Thomas her father. T was powerful.

However, she could not proceed to drawing other letters. T was the last letter she could remember.

I could no longer really read nor write. When I was with my white family my life from around the age of ten, except for some winter evenings, had been hard and crowded with labors. Mother was particular in every respect; each minute, it seemed, there was something to be scrubbed down or winnowed, something to be split or bundled. As

my brothers and sisters were born, I as the eldest became their caretaker.

Father read to us from the Bible almost every day while Mother and I sewed. Both my parents often quoted long Scripture passages by heart. I desired to read more on my own, but I rarely had time. My hold on reading and writing, then, was fragile even before my capture.

SHE REMEMBERED the Bible, its pages, and the smell a little like damp splinters of wood and the way fingers could slip across those pages or linger on them, the way she would slightly bend her index finger and put its tip to the corner of a page and turn and the soft snapping sound of that turning and then another white page, more paper.

I had loved the gray-black letters on the page, their straight lines and curves, the pride of knowing them and the questions they raised, and the thoughts.

JESUS had obviously had thoughts. Jesus had said, "Woe unto you, scribes and pharisees, hypocrites! For ye pay tithe of mint, and anise, and cummin, and have

omitted the weightier matters of the law, judgment, mercy, and faith. . . ."

Jesus said exactly what he thought. Why had her mother hushed her for doing the same?

Amazing that Jesus had known the names of the different herbs.

All the record of these things lost to me forever. My white mother's dismay when she appeared in my dreams was warranted. Why had I not been more diligent in reading and writing at home? Why had I succumbed to sleep at night instead of holding my lamp above the pages?

BUT WHAT if she could still, for instance, write? She had thought of telling her story. What would people think?

It was a fact: she could no longer read nor write. So she would have to do something different to satisfy her heart. She would have to find new ways. Grieving for reading and writing was like doing the previous thing, the thing that could no longer be done. Old it was, and impossible.

She would cut herself free of a yearning that could waste her, she would scrape it off with the nearest thing to hand, say, a beaver-tooth tool.

There. The previous thing was shed now, had dropped away, was lost and gone. Let it be lost. Her heart would move on. For she loved the world.

She loved the open air and the contrasts of its temperatures; earth dry and sodden, loamy and rock-like; fire and its warmth and scorch; water, cleansing and flooding. The closer she came to these things the more she realized that words were not the same as the real wild onion, the actual rabbit fur, the coiled fern frond, the lightning.

I had never known moss as I learned to know it among the Seneca. From my new family I learned to diaper my babies with it. Moss was soft and did not irritate the skin. It held much of the wettings and dried out quickly. I had known the word for moss first in English and then in Seneca and I had seen moss and had touched it, but only now, dressing my own baby with it, did I know it. And the word "moss" was but the richer in my sight.

It came to me that I could listen, could memorize, could speak, could tell stories, could sing, and that in two languages, to be sure. That was what I would do. I would not let one word escape me; I would speak new words aloud as I learned them so as not to forget them.

I would pay attention to the human voice; I myself

would speak carefully and expressively; I would never mumble. And I could give my children this gift: the words, the names, the arrangements of words, the pitches—rising notes, falling notes. I would teach them about the world using my ears, my throat and tongue.

I would speak the things of the earth out loud, so loud that the moon itself would feel called upon and would incline to my signals.

AND SO she played naming games and singing games with her children, starting with corn, which was their daily companion. Mary said in English the names of varieties of corn planted by their different nations and the children would answer her, would repeat:

> *"short-eared"*
> > *"short-eared"*
>
> *"purple-blue bear"*
> > *"purple-blue bear"*
>
> *"Mohawk red-and-soft"*
> > *"Mohawk red-and-soft"*
>
> *"calico"*
> > *"calico"*

"black sweet"
 "black sweet"

"red pop"
 "red pop"

"white flint"
 "white flint"

"Now sing this: Rejoicing, rejoicing, our family is rejoicing, bringing in the corn."

"Rejoicing, rejoicing, our family is rejoicing, bringing in the corn."

I wrote what I thought was the tune for this line in the dirt:

• • ' • • • ' • • • • • • ' • • • • • • • •

I suddenly realized that this line set to this tune had been in my head for some time. As had other lines in Seneca and in English, set to other tunes.

Was an interior singing of which one was at first unaware a sign of being happy? Perhaps the surest sign.

"MOTHER," Jesse said, "make us some of that red pop kind of corn."

THE CORN became her children's catechism:

"What will happen to us after death, Betsey?"

"After death, we return to the ground as seeds, and when our seedcases split we are those shoots which rush through the dark earth toward the light, only to find ourselves in heaven with the Good Spirit forever."

"And who is the Good Spirit, Thomas?"

"The Good Spirit is the best of male and female in one. It is in all things without being captive to things; all things are in it."

Then Polly, who cried at the slightest affliction, had her own catechism question: "Does the Good Spirit ever cry?" The children all turned to their mother.

"Yes. The Good Spirit does cry. The Good Spirit feels sad that we cannot understand what it is doing sometimes, that we can see only the underside of the dyed and woven floor mat of the heavens and not the design on the top."

Jesse, who had been fidgeting until he heard the words "cry" and "mat," asked if the Good Spirit ever laughed.

"Yes. The Good Spirit especially loves a humorous story."

When I heard some new word, whether it was French, Seneca, Dutch, English, or Delaware or Shawnee, I would stop the speaker: "Stop. What? What did you say? Excuse me?"

"Excuse me? What is 'citrouille'*?"*

AND THE word would go to her children. "I have a new word, in French, for you. Pronounce after me: *'citrouille.'*"

"*Citrouille.*"

"Again?"

"*Citrouille.*"

"Again."

"*CITROUILLE.*"

"*'Citrouille'* is the same as our orange squash, and I think it means 'pumpkin' in English. Say it."

"Pumpkin!"

"Again?"

"Pumpkin, pumpkin, pumpkin." The children giggled.

Then John said, "'Pumpkin' makes me feel very hungry."

"I'm hungry, too," Jesse said. Her boys were always hungry. "I want some cooked orange squash and corn and beans. The Three Sisters."

"I want the berries that are sky-colored," Betsey said.

"I want the men's RUM," John said, and they all laughed.

In this way, she would interrupt someone and demand to know what a leatherapron was: "Stop. Excuse me? A what? Why are you calling a person a leatherapron?"

She learned "matchlock," the nature of the "Dutch Continental Sunday," and "waterwheel." She lay down at night with "indentured," "cusp," and "spume."

The Seneca had stories about a creature called the Skeleton, who, as long as his bones lay aboveground on a pallet-bunk in his isolated hut, had feasted at night on the bodies of wayfarers who stopped for shelter. Once the Skeleton was buried he lost his envious, ravenous tendencies.

She would not lie down aboveground, watch for wayfarers, envy them, and suck their blood. She would not lie about on the rotting pallet-bunk, unconscious and restless, indecisive and preying.

She would go deep into the earth from the beginning and do what she could and learn what she could and hand that back to others. Feed them, speak to them, instead of biting their necks.

I realized that I was thinking of staying on the Genesee. If I did so, I would have to accept what one Frenchman had

called me at the time of my capture: l'autre. *That one, that one over there,* l'autre.

In like fashion, I would take seriously what I had heard a missionary say of me one day: "There's a strange one."

I would be somewhat strange.

PEACE lay on the Genesee, and after a year's time a festal day occurred in which the Seneca people celebrated the achievements of the past. Hiokatoo was the summoner and spoke from a platform.

"This day is a memorial to strength. We will dance, we will dine well, but we will also engage in mock battle and in contests. We will show that our bodies have stayed strong and lithe. We can better discern who among us may be our future chiefs." He raised his voice. "Keep perfecting your Seneca language. Preserve and hand on to your children the theory and practice of warfare. And in your sacrifices give homage to the Great-Good-and-Beautiful Spirit."

Then Hiokatoo extended his arms over his head and leapt forward. The crowd was silent. "Let the games and rites begin."

In answer, polished scalping knives and tomahawks were raised and shone in the sun. Hiokatoo stepped back and his arms fell to his sides as if he were exhausted.

═

She watched the games, the races, the enacted ambushes, the dancing and face paintings, and finally she turned to the far field where Hiokatoo was drawing a crowd. He was doing a kind of pantomime or "dumb show," and he was all wrists: she saw that he was performing a mock tomahawking. Those wrists with their immense suppleness made the tomahawk and scalping blade rotate and swivel so as to hone close to bone, to cleave and carve out a wedge of scalp. He punctuated ritual scalping after scalping by throwing his instruments into the air and catching them with sudden clutching movements. In all of this, his dignity was greater than that of any scepter-wielding king.

Finally he packed his trophies into an imaginary bag.

"YOU WATCHED too closely." Tree looked at Mary's face. "He told you he was a fierce warrior. Was that not enough? You watched too closely."

"He seemed to me kind and gentle."

Then Tree sighed and told her that he was tender with his friends. Further, she said that Mary had looked for kindness and gentleness, that she had wanted to know "kind" and "gentle" and had not on the other hand wanted to see the fierceness of which her new hus-

band himself had spoken. Mary had not wanted to know the facts—that he had earlier practiced the art of war on everything hostile that fell into his hands.

For the next days I avoided Hiokatoo as much as I could. I was aimless and restless and the specter of leaving the Genesee gripped me again so that I would sweat and want to die. Almost worse than these feelings was the knowledge that I had just a year or so before resolved that I would accept my life as settled.

It was Hiokatoo's fault. I told myself that I had made a mistake in marrying him. And once, I caught myself thinking that I hated him.

"YOU DO not look at me," Hiokatoo said. "You will not meet your husband's gaze." He waited for a reply, and when it did not come his shoulders slumped. He looked to one side of his wife and continued: "My young sinews were formed for strength, for war. And war itself further formed them. I loved combat, the ambush thrilled me, and also the spoiling of my enemies." He looked right at Mary and spoke deliberately. "Sometimes our enemies were held at bay with just the stories about my furious assaults."

Mary returned his gaze, and at this he sat up straight

and leaned slightly forward toward her. He lowered his voice. "I know you lost your white family. I was carried away during the festival. To be a warrior at all you have to want to win. You must want success. Your nerves have to be finely strung. My nerves were remembering my younger days."

He had never seen her look so weary. She finally spoke. "But you have blunted your feelings."

"And you have never blunted yours? But yes. I will not cover up my excesses. However, I was born into those times to be a warrior and a fast runner. The Great Spirit knows this."

He considered his hands for a moment and then told his wife that he did not wish her pain, that she should perhaps watch the games no more, that in general perhaps she watched things too closely and that it was not bad, at times, to turn her head.

Mary lifted her chin. "Only I can decide when to turn my head and when not to turn from these things."

In this manner, they partly understood each other.

From this and other events I learned that words, love them as I did, would not protect me from feelings. Once I had seen a three-legged doe stumbling, trying to make its way across a clearing. Words would not protect me from revisitings of the three-legged doe whose name was Doubt.

IN A short time it appeared that the ritual games and practices might serve the ends of actual war once again. At the council at the German Flats the American colonists told the Six Nations that they were resolved to press their grievances with the King of England. They did not ask the Iroquois to help them but asked them only what they would do should the colonists reach the snapping point with the British.

The Six Nations conferred. Then the Oneida chief as spokesperson reported that if a war should break out they would not take up the tomahawk and the scalping knife against either side.

THE RAIN, soft and warm, was nonetheless steady. Hiokatoo paused just inside the hut door and listened to his wife, who was sitting with the children.

"And then the mud-turtle accepted the pregnant young woman who had fallen from the sky onto his back. In the days that followed, he allowed the birds and other creatures to bring seeds, saplings, and ripped-up pieces of earth and to plaster these things on his back. The mud-turtle grew larger and larger.

"After a great deal of swimming, the mud-turtle spoke and said to the Good Spirit: 'I feel the world on my back wobbling a little. I am afraid. It will take much concentration and care on my part to keep things in balance. No longer may I be heedless; no longer may I swim recklessly and play at will, risk bumping into shoals and whales, make sudden jerking movements.'

"But the Good Spirit spoke and said to the turtle: 'Of course. What do you expect, being honored as the bearer of the world into the future of its men and women? Did you expect the young earth on your back

not to wobble from time to time? I tell you that it is the condition of all things in this present life, of all creatures that creep and crawl, of all women, of all men, of all children, to wobble.' "

Jane looked up, saw Hiokatoo, and said in a loud, bold voice: "Even my father? Is it the condition even of my father to wobble?"

The thought of wobbling on the part of their massive father, the father who kept his shining tomahawk next to their parents' pallet, made the children's mouths open.

Then Hiokatoo began moving from side to side. He stepped forward and moved his hips; he stepped forward again and lost his balance. He staggered.

His children shrieked.

Hiokatoo frowned deeply. "What is this? You laugh at the Great Wobbler?"

The children yelled.

Then their father stooped, reached past their mother, and touched each child lightly on the forehead.

Later he said to his wife, "I hardly recognized that story. You are changing the great Seneca turtle legend."

"As Senecas before me have changed it," she replied.

His countenance changed.

"Did my answer anger you?"

"No," he said. "I came to ask you to go to Oswego with me."

"Oswego? Why?"

"To a council."

"A council?"

"The people," he said, "of the colonies have risen up against the English king."

"WE ASK your help," the British commissioner said, "in putting a stop to this rebellion." As he spoke from the center of the council circle, he moved about and waved his arms in an expansive manner. "It is an evil uprising; it will destroy the normal order of things."

He stopped speaking, for he had caught sight of Mary sitting just outside the council circle. Who was this? One of his own held against her will? A spy trying to disguise herself as an Iroquois? Though she was tanned, her hair and eyes betrayed her. A rebel sympathizer? He frowned and turned to his compatriot, who shrugged.

An Oneida chief rose and held up his hand. "We know you are aware," he said, "that the Six Nations have conferred: we will not enter the thickets of this dispute."

"Do not think," the commissioner continued as if the Oneida had not spoken, "that the Nations will profit little from assisting King George. He has sworn that in exchange for your famous warring skills, his vast resources will be always at your disposal: if your maize is blasted by downpours or drought, he will send food to nourish you and your children. He will supply you with

guns and gunpowder for your days, and when you return to your homes at nightfall, rum will await you. If you join with us, each man"—and he looked pointedly at Mary—"will today have a pledge of the king's good intentions. In addition to what you are about to see, you will receive money, a bounty payment for each rebel scalp you present to us."

Hiokatoo turned his head and looked at his wife. Her face was expressionless.

The Englishman pointed toward his chief officer, who was opening a large bundle which lay at his feet. He unwrapped and held up in turn a full suit of clothes, a brass kettle, a gun with an accompanying vessel of powder and lead, a tomahawk, a scalping knife, and something that looked like a flake of gold.

The council circle could hear behind them some murmurs of admiration and approval from their people. A few came forward to look more closely at the pledge-bundle.

In the end, the Six Nations agreed to aid the British.

"THEY know better."

Hiokatoo had been raising a piece of bread to his mouth, but he stopped his hand in midair and looked at his wife.

"How could this have happened? Earlier we made a treaty that said we would not take up with either side.

How could you let this happen? Why did you not speak? I should have spoken."

Hiokatoo's jaw moved to one side; he laid the piece of bread on their eating-mat before he answered. "Many of our people believed the promise that their future would be secure from want."

"They know better."

Hiokatoo turned as if to let her anger slide past him. He raised his eyebrows, but his wife did not take the warning.

"You must not have heard correctly. Our people would never have done this."

In response her husband placed his hand back on his bread and then asked Mary a question. "Who are you talking to?"

"Who am I talking to?"

"Yes."

"What do you mean?"

"Who are you talking to? To yourself? To someone else who is not present in this room? I am your husband and a Seneca. Are you saying that you know the Seneca better than I do?"

THE FOLLOWING May the Seneca fought their first battle with the colonists. That year Mary saw many white prisoners, but a day came when a war party entered the village and brought one of the strangest of them all—a man dignified and bearded. He was in the company of three white women and several children.

He conveyed a singular sense of evenness, of a steady and sure and unnatural presence under the pressure of captivity. The look he gave me as he passed was frank if not bold. He nodded to me and smiled, and the smile was of an assured and at once intimate and invasive nature.

He did not speak, but it was as if he had. It was as if he was saying that he would take care of me, that I should make some kind of arrangement to spend time with him.

BEFORE the prisoners were led off, the leader of the war party spoke to the chief's son and said that the prisoner was Joseph Smith. And he said that the others were rumored to be Joseph Smith's disciples.

IN THE center of a cornfield, a flame was laid to a dry cornstalk. And then other flames were laid to the field's four corners.

This was the beginning of the colonial Sullivan expedition, and the rebels' path led through Genesee, where the Seneca had gone over to the British. Field after field flamed up, and axes were put to the trunks of the apple and cherry trees.

Just days ahead of these actions, the Seneca had held a council: they finally and sadly determined that Sullivan's forces would outnumber and overwhelm them. All the women and children were then directed to leave immediately and travel the long journey to the banks of a creek called Catawba, while most of the warriors hid themselves only a short distance from the Genesee River.

If my people suffered, so did some of Sullivan's men. According to my husband, Lieutenant William Boyd fell into the hands of one of our cruelest warriors, Little Beard.

Boyd was tied to a young tree and Little Beard and his companions threw tomahawks at that tree, aiming for points close to the poor man's body. But the worst was to come.

A scalping knife was laid to the lieutenant's abdomen in order to make a slit about three inches wide. Then a warrior inserted two fingers in the slit and groped about like a surgeon until he could hook his fingers around the intestine, which he drew out. "Look," he said. "Ha. This infant has a very long birth cord." He severed the intestine and tied one end to a sturdy branch of the tree; Boyd was released and then whipped and pushed around and around the oak until all of his bowels were pulled out. When Hiokatoo heard this story, even he wondered at the ferocity of such torture.

AFTER Sullivan moved back off to the east, the Seneca returned, expecting some semblance of their village and finding nothing but charred wood and rusted kettles. When Mary arrived back one late afternoon she saw two men who were digging here and there, trying to uncover whatever was left of their homes.

They did not know where Hiokatoo was but knew that Sullivan's forces had found their people's food cache. They also knew that Mary's hut had burned to the ground and told her as much.

Close-Eye, without ceasing his digging, said, "Go see where your hut once was. There's nothing there."

Mary didn't move.

He stopped his work, straightened, lifted his head, and looked at her through his half-closed eyes. "We will all starve now." He shifted his gaze to the children.

She considered this for the space of a few seconds. "Yes, we will all starve if we sit still or keep on digging in the same spot. I will not sit still."

"Pah!" he replied. "Where do you think you will go?" He spat. "Maybe now you will consider running back to the whites. If they will take you. Some people call you the white witch."

But Mary and her children were already walking off.

The sound of a dull clank followed her. The blade of the bent hoe which Close-Eye's fellow digger was using had struck the top of a skull.

"Look," Close-Eye called after her, "at what your people have done to us here. Maybe Sullivan is your relative."

About ten minutes later, her little Jesse pulled on her skirt and she picked him up. "I am so hungry," he said, "I would even eat False Face Pudding."

Jesse would not eat False Face Pudding, cornmeal cooked with maple sugar and sunflower oil, which was prepared for False Face dances. Her other children were fascinated by the False Faces themselves, giggled when the dancers performed, and tried to make little masks

from birch bark to use in their games; but Jesse was terrified by the False Faces, by their cavortings, their healings and other ministrations. And he shunned a pudding that he otherwise would have liked very much, for he loved the sugar of maples.

THROUGH the drizzle, light, and then the shape of the cabin that contained it. And the choice was to knock and hope that someone would take them in for the night.

The woman who opened the door had very dark brown skin, and Mary's children, their clothes sodden and their hair flat from rain, looked at her solemnly. Then the door was wider and the woman's name was Cleopha and she and her younger brother, Simon, served them a soup made from dried white beans.

Later that night Mary learned that Cleopha, Simon, and their brother, James, had been slaves in Virginia, that they had departed their master's house one night, that dogs had been loosed, that James had fallen behind, that they had had to leave him. There had been no food, no rest for many days. And Simon had not spoken a word since.

In the morning Cleopha had a plan to offer. "We have a large field of corn we have not harvested. You could stay with us and help us—"

She stopped, for Mary looked doubtfully at her.

"For pay," she added.

"For pay?"

"Yes. We will pay you. In corn. For you and your family."

Before long I grew to love my employers with all my heart, and I believe that they were fond of me and of Thomas, Jane, Polly, John, Betsey, and Jesse. The cabin was crowded, but no one seemed to mind. I knew I could feed my children, and hence I stepped with a light foot into the corn hillocks each morning.

My dear young ones showed Simon and Cleopha our people's way of picking corn—the plucking of the ears and throwing of them over the left shoulder into great harvesting baskets which they carried on their backs. Cleopha stood with one hand on her hip and frowned at this and finally smiled and in the end laughed at what seemed to her a peculiar method, but Simon from the start was all merriment, joined right in, and laughed a laugh which must be called hearty even though it was entirely silent.

I noticed that Simon carried a gun with him to our labors in the corn, and I asked Cleopha why he did this, to which she replied that she had never seen him do it before our days together with them. "Perhaps," she said, smiling,

"my brother thinks that though I was never worth protect-
ing, you and your children are."

Later I determined to ask Simon myself, and when an
appropriate time offered itself, I did so. He usually made
quick gestures as a way of conversing with all of us. Now he
looked thoughtful. He raised his hands to his face, spread
his long fingers and placed their tips on either side of his
nose, then drew the tips slowly across his cheeks until they
rested close to his ears. I did not understand, and he saw
this at once because he repeated the gesture, but first he
bent to the hearth and put his fingers into the cold ashes.

"Simon—war paint? War paint!"

Beneath his ashy war paint, Simon looked grave.

"You are protecting me—surely not from the
Indians!"

He nodded.

"But, Simon, I am one of the Indians. I am a Seneca.
You know my story."

He looked at her.

Each day Simon continued to appear in the fields carrying
the well-polished gun in his huge, sure grip.

MARY said, "Simon is stubborn."

Cleopha, who had become as a sister to Mary, said, "I have lived with my brother for a long time. He is more than stubborn."

"Cleopha, we must get him to talk. We must. He can talk. He is such a careful listener. Have you watched his eyes, his posture, when someone speaks?"

"It is useless to try." Cleopha turned back to where, with Jane, she was slicing pumpkin pieces into thin, curling lengths and hanging them above the fireplace to dry.

"I will try."

"Better not. He knows you want him to speak, and he will resist all the more."

"I can get him to speak."

A pumpkin spiral dropped to the floor. Cleopha sighed. "Because you have suffered so much hardship, you think you can do anything. One of these days your pride will make you stumble. No one can do everything. Haven't you learned that yet? Simon himself must choose to speak or not to speak. Leave him alone." She turned away from Mary, who looked at Jane and found that her daughter was looking right back at her.

Simon, I noticed, spent a good deal of time gazing at a scrap of water-stained almanac that had been left in the

cabin. I watched him as he walked about outside staring up at the moon in all of its phases, and I decided he was a student of the night skies as I had once been a student of snow.

"SIMON," Mary, said, "I heard you speak in your sleep last night."

His face fell.

"That must mean you can speak."

He shook his head; he drew back from her; fright spread across his face.

"You spoke."

Again he shook his head.

"You said there would be a full moon tonight."

He shook his head. Now he looked angry.

"That's what you said."

He clenched his fists.

"That is what you said. I heard it." She folded her arms. "You woke me up, you were talking so loud. You must be able to talk, after all. You said, 'This night there will be a perfectly full moon.'"

He shook his head.

She persisted. "I heard you."

He exploded. "N-N-NO."

"What?"

"NO. The m-moon is not full yet."

WHEN Cleopha came in she said, "Jesus Lord!" Then she said, "You tricked him. I don't know that you did right. Maybe he wasn't ready to start talking."

IN THE spring they all worked to build a house for Mary and her children, and on a day when they were dragging boards from the mill at the outlet of Silver Lake, Simon stiffened and pulled his gun from his shoulder.

A lone figure walked determinedly, if in a wavering way, across a field toward them.

"An Indian," Simon said.

It was Hiokatoo. It was as if he had risen from the earth, the tall grass parting to reveal him the way it parted when a bird flew up at dusk.

Hiokatoo's hand fit into hers just as before, just as if nothing had happened. Before Mary could tell him Simon's story, he said, "Why does that man talk all the time?"

MONTHS later a day went by and Simon had not come to see them. Mary and Hiokatoo went to the old

cabin to see if he was ill and found both Cleopha and her brother sorting through their possessions.

"What is this? Simon, you didn't come to see us today."

And Cleopha answered, "He was too sad."

"Too sad?"

Simon looked to one side.

Cleopha continued, "We are getting ready to leave."

"Leave?"

"We just," Cleopha said, "talked and we just thought there might be places we haven't seen that would suit us better."

"Which places?" Mary said with such sharpness that her husband looked at her.

"We don't know."

"You don't know?" She stepped close to Simon. "Simon? Which places?" Mary turned to Cleopha. "Cleopha. You don't know where you're going?"

"Somewhere further north."

"But," Mary said, "this is a good place."

"Well, yes, this is a good place—"

"Well, then—" She felt her husband put his arm around her in a gesture of gentle remonstrance, and she knew she must be sounding shrill. But she persisted.

"Simon?"

He turned around but looked at the floor and said nothing.

"He's afraid," Cleopha said.

"Afraid?"

"He's afraid we are upsetting you."

Mary sighed and considered.

Simon looked at her.

"I know," she said, "that you want to go now. You don't want to live in one place all your life. You're free. I understand. Here in the north you are free."

*"If you do not do what your heart desires in America,"
I said to Simon, "what is the use of its being a free
country?"*

"GOOD-BYE, Miss Mary." Simon had never called her that before. "We're leaving now."

And he looked briefly in Hiokatoo's direction before he gazed at Mary in a way that dared her to ignore what he was about to say. "You always have advice for the rest of us. But you haven't spoken of yourself lately, of owning your own land. Why? Because your husband has returned? If you told him your dream, I think he would understand and even join with you to get what you want. 'If you do not do what your heart desires in America, what is the use of its being a free country?' You yourself have said it."

AFTER Cleopha and Simon had been gone for weeks, Hiokatoo said to Mary, "The man loved you."

"What?"

"Simon loved you."

"I also loved him. He was my friend."

Hiokatoo waved his hand back and forth as if he were fanning himself. "He was always looking at you when you were unawares. He had grown so attached to you that it troubled him. That is why he left this place."

AFTER the Revolutionary War, doing what their hearts desired led more and more whites toward the fertile, tilted Allegheny Plateau. Mary had seen dozens of them pass through the Genesee Valley: prospectors and traders, madmen, lawbreakers, surveyors, the disaffected. But now some stayed, worked the rich soil, trapped, and built small houses. Complete families began to arrive.

I became acquainted with the whites who settled near the river, and sometimes they came to our house to ask about the herbs that made good medicines or to consult Hiokatoo about the best uses for different hardwoods. I enjoyed their visits, even though I sometimes felt they came because I was a curiosity to them. Once a little girl asked me if I was the "white woman of the Genesee" and I said, "Yes, I suppose I am." Then I followed by saying, "I am also a Seneca. And who are you?"

"I am Irish," she said.

"Ah." So I told her that tale about the farmer and the

horse named Coinn and the drawbridge. But I changed the part about the corpse. I had a sleeping maiden come floating down the little stream instead. And I invented an ending.

ONE EVENING Thomas, who had his own small house now, came through Mary's door with a man named Ebenezer Allen, a Tory who had come to their flats not knowing quite how to ally himself since the severance from England. Allen was fairly short and passingly handsome in a somewhat girlish way.

He was the strangest man I ever knew. He lived with Thomas for a time and appeared daily to help Hiokatoo and me with our chores on the land. He also journeyed to Philadelphia for goods and traded them to our people in exchange for ginseng root, which he took back to the city and sold for a high price.

His manner was generally pleasant, but in time I came to see him as moody and restless. He spoke in a whining manner of all the injustices done him.

ALLEN also often appeared at the home of a white man and his Nanticoke wife, whom he helped during the day

while her husband drove his cattle some distance so that they could feed on rushes. The Nanticoke, who had taken the English name of Priscilla, was so grateful to Allen for his help that for many days she worked at making a special hat to keep him warm, for she noticed that he went about bareheaded in the winter. The hat was crimson and when it was made she decorated it.

Her husband had seen Priscilla sewing the hat and had assumed it was for him. When he came home with the cattle one day, he saw something moving on the horizon and that something was tipped with red. When he discovered it was Allen wearing the beautiful new hat, he flew into a rage and decided that in his absences he had over and over again been made a cuckold, which we were certain was not true.

Instead of pursuing Allen, he went straight home, held his wife still while he wrapped her long black braid round and round his hand, and then jerked on it and by this method dragged the innocent woman forty rods to our house, where he left her, bruised and humiliated, on our doorstep.

Now I saw something that I had not seen in a long time. Hiokatoo picked up his tomahawk once again. He was much incensed by the unjust treatment of Priscilla at

the hands of her husband, and he threatened him and bade him to depart, saying, "Jogo!" which means "go off." That man, knowing Hiokatoo as he did, went straightaway.

Allen, in fact, had never touched Priscilla, nor she him. But later he drowned an old man who had a young wife whom Allen coveted, even though he had married by then.

 And later still, stories came to us illustrating that he had been unexcelled in his cruelties toward the revolutionaries. One time when he was scouting in the early morning he came upon the house of a colonist who was known to be fighting the British: he went in at the door, killed that man, cut off his head, and threw that head into the bed where the poor wife lay with an infant. Then he took the baby, shook it until its neck snapped, and tossed the small body into the embers on the hearth.

 Once when I repeated these events to him, remarking that it could not be the truth and that he should know that someone was busy blackening his name, he answered and said that the story was correct.

 And he added, "I should not have done that. But I want to know exactly who is spreading these tales. Someone, no doubt, who has a grudge against me; someone who is trying to diminish my importance, my position in this valley."

 A day later he stood on my doorstep and said, "Besides, you yourself have done some strange things. You know what they say about you and that mute Negro, don't you? They

say you may be a witch. Or some sort of ghost." He laughed. "Here you're white enough to pass for one."

Before I silenced him for weeks with a cutting remark, I stopped to ask, " 'Mute'? What does that mean?"

IN THE next years Hiokatoo grew thin and feeble and all but lost his eyesight. Sometimes Mary longed for Cleopha and Simon, but especially for Simon, who had often been her companion on long walks on the flats. Now she went out by herself and returned to hear her husband breathing hard.

Finally, when Mary heard that an Albany doctor was in the area, she summoned him to examine Hiokatoo, and when he arrived he looked at his patient and then doubtfully at what was obviously a white woman.

"This old man is your husband?"

"Yes."

"How long have you been married?"

Hiokatoo saw only shapes now, but at this he lifted his head to fix the precise outline of the physician.

"A long time," Mary said, looking at her husband.

"Well." The doctor looked as if he was not sure he wanted to hear the details of this story. "Well," he repeated in almost a whisper, "this—Indian man has a heart that is failing him. It is a congestive condition."

"Excuse me," she said. "What is 'congestive'?"

"His heart is weak," the doctor said again in a whisper, "and his lungs therefore suffer."

Hiokatoo had a sonorous and harsh voice that carried across a whole field. Not for nothing had his whoop terrified Indians and whites and all who heard it. Now he drew himself up. "I," he said—and the doctor took a step backward—"I may be blinded, but my ears are large and my powers of hearing are untouched. Address me when you speak of my own bodily illnesses."

HER HUSBAND lost his taste for food but not for talk. His one satisfaction consisted in the telling of stories.

His dear, huge body began to shrivel, but as he talked his mind, as if taking sustenance from that which wasted, seemed to kindle. I repented me in my heart for moments of impatience with him, for wishing he was other than he was, for wishing he was younger than some ninety years, for wishing he was Simon or some other man.

He was the noble, fierce Hiokatoo forever. He was also the Hiokatoo of the tender touch; he especially liked to lift

his hand and brush my hair and the hair of our children,
should it be hanging close to our eyes, back from our faces.
The lightness, the fineness of Jane's hair always seemed to
astonish him.

Once we obtained a hairbrush from a trader, and he
often held it, felt the weight of it, touched its back, its bris-
tles, its handle. He became the keeper of the brush and
seized any excuse to solemnly neaten our hair with it. He
was ever kind to us and to his friends.

But sometimes in later years he tested me with his tales and
the repeating of his tales. I will be able to recount them in
detail until the day I leave this earth for a fuller life with
the Good Spirit.

WHEN she sat with him, she could tell that he was
preparing to tell a story by the workings of his arthritic
right hand. He would make as if to grasp with it in slow
motion, as if to make it into a loose fist. Then he would
relax this hand and open its fingers. As she saw him
repeat this process over and over, it appeared to her that
his hand was acting as a lung or a bellows might act.

One of his favorite stories was that of the campaign
against the Catawba. "I was a runner and scout," he
would begin, and then if any visitors were in our house,
he would say, "Two-Falling, tell them what year you
think this was."

"About 1731."

"About 1731. We had set our faces against the Catawba and the Cherokee—we needed the use of their hunting grounds. At the mouth of the Red River, at the place called the 'low, dark, and bloody lands,' my friend and I discovered that the Catawba had word of our war-venture and had set an ambuscade. We had to keep ourselves from shrieking out our joy, from yelling out the scalp-whoop as we made our way back to our brothers. We trembled and smiled and smiled. We had a great secret between us." Hiokatoo's face was shining.

"Twelve hundred. When we swept down on the ambuscade from the rear, we fought for two days and many of us fell, but by the great sunglobe's setting on the second day we had massacred twelve hundred Catawba."

His hand contracted and relaxed, contracted and relaxed. Mary folded her arms.

"From that day"—Hiokatoo's face registered a kind of awe—"after those two or three days, the Catawba were heard of less and less. Now they are no more."

And if a visitor was present, say, some kindly white neighbor who came from time to time to keep him company, he would lean forward; if he could have seen to clutch someone's sleeve, he would have done so. "Now," he said, "tell me this. Had you ever heard of the Catawba before this day?" His unseeing eyes, under the folds of lids, were set; they nearly glittered in anticipation.

"No," the visitor would say, "I have not."

"No. See? You have not. Because of that very massacre at the place that I think is now called Clarksville. Do you know," he would say without pausing, "what most of us fought with in those days?"

"No. Tomahawks?"

"The bow and the arrow. Those were the days of the bow and the arrow."

These wars against foreign tribes was always the topic of conversation when whites were present. His hand would announce the story.

"Once—once we took some Indian prisoners and tied them up. Then we let little boys shoot arrows at them, for practice. The boys were clumsy with their bows and they had to shoot many arrows before those Indians died."

Here there would be silence.

Hiokatoo's hand would open and close, open and close until he spoke his next sentence. "But of course you know about the French war."

The visitor would say yes, of course, he knew about the French war.

"Do you know something about that?" Hiokatoo said.

"What is that?"

"I was at every river battle."

"River battle."

"I was at every battle fought on the Susque-

hanna and Ohio Rivers during the French war. Every one."

"Oh, my," our visitor would say.

And the next day and the next I would enter our home and hear him saying to someone, "Now tell me this. Have you ever heard of the Catawba before this day?"

"No, I don't think so."

"No. See? You have not. Because of that very massacre at the place that I think is now called Clarksville."

WHEN Seneca people were present in our home, he spoke of his exploits not against Indians but against the whites. He had a part in Braddock's defeat; he helped take Fort Freeland, where he scalped many of the pale people.

SCALPS. The scalps Mary had seen were various: most of them were about the size of her hand, but some were much bigger, and once she saw one so large that the ears were attached. Some had been incised and then carefully lifted from the crowns of the victims' heads; others she could tell had been crudely cut, a kind of hacked outline having been made before the scalp was ripped off like a hull. A few of the victims, to everyone's

amazement, had survived scalping; these walked about, humiliated, in caps always.

Her father had never told her that the whites sometimes scalped, too. He must have hidden this from her. Now she knew better. French, British, and rebel colonists all announced bounties and set prices.

I did not pay much attention to Hiokatoo's stories because I had heard them so often. One day an acquaintance accused me of being callous, of numbing my feelings about my lost white family.

Before I could consider this, I found myself saying, "Time is the aloe laid to every inflammation."

But not time only.

When I was captured and hurried across our fields, departing them forever, they looked as they had always looked. In later days the fact that I was a prisoner had not stopped the breeze nor the tubers which grow sequestered in the dark ground nor darkness itself nor the flutterings of moths nor the reedy songs of children nor the pungency of sage.

At first I was a speechless captive; then I took joy from speech. But before I was speechless and before I spoke, things existed. Someone else had spoken. Knowing this, I grasped

my sorrows as someone would grasp arrows, and I was comforted.

Under the words are real roots and impending leaves. Under the wounds are sinews and bones.

In the body and out of the body but not of the body, the spirit circles and expands, refuses and allows. And sometimes in spite of itself the spirit laughs out loud and sometimes in spite of itself it groans; but always, even in bonds, even if muffled, it presides.

I do not know how much others suffer; whether it be more or less, whether it be deeper or shallower than the suffering I now own. Is there a right way to suffer? These things do not partake of measurement nor the comparisons that often lead to great, unfortunate levelings.

"The Heavens," it is written, "declare the glory of God: and the firmament sheweth his handywork. Day unto day uttereth speech, and night unto night sheweth knowledge. There is no speech nor language, where their voice is not heard."

The firmament revealeth the mud-turtle, noble and dignified in its slime.

I will not open these wounds again so as to satisfy anyone's idea of what it is to be human.

"I OFFER you your liberty."

"What did you say?"

"I offer you your liberty." Her brother, the hot-headed Black Coals, smiled.

"It is yours to offer?" As soon as Mary had asked this, she realized she might have offended her brother. But the irony escaped him and he told her, yes, he was offering her, his sister, freedom.

His face was kind and old, and out of love and courtesy she took no issue with him, saying she would think on it. Three days later, without discussing this with Hiokatoo, she thanked her brother but said that she had made up her mind to stay at Genesee. And then she told him something she had never told him: "I had thought of moving on and trying to settle myself on land of my own, but I cannot have all things in this life."

Black Coals was well pleased with his sister's resolve. One day he told her that they should apply to the great council at Big-Tree for a parcel of land.

"What?"

"Why did you never tell me," he said, "that you would like some land? I can't help you get what you don't ask for."

She assumed that he meant that if they were successful they would own it together, but Black Coals stood with his hands in his pockets and said no, that the land should be hers.

"Mine?"

"Yours alone."

"And Hiokatoo's as well?"

"No. Yours. I know you will take good care of your husband."

BECAUSE she had summoned up tact of heart for her aging brother, because she had not reproved him for his offer of freedom, she found herself pacing off a boundary.

She knew what she wanted. She walked; she looked. She judged. She would walk and then turn sharply and walk off again in a straight line. What she wanted included streams with brown trout, fields for her and her family, fields she could lease, stands of trees, and hills and valleys, including one great hill and one great valley.

=

While she was measuring off her land, Black Coals was sickening. He died at Grand River, but not before he had enlisted the aid of his friend, Farmer's Brother, to work with Mary on the negotiations at Big-Tree.

AND SO in 1797, Mary, known to her French captors as *l'autre,* known to the Seneca as Two-Falling-Voices, known to her first husband as Two, known to her second husband as Two-Falling; known to her white neighbors as Mary; known to her white solicitor, because of his conservative stubbornness, as Mrs. Jemison; known to her children as Mother; came to own land: more than ten thousand acres.

My land derived its name, Gardow, from a hill that is within its limits, which is called in the Seneca language Kau-tam. Kautam *when interpreted signifies "up and down," or "down and up," and is applied to a hill that you will ascend and descend in passing it—or to a valley.*

WHEN Mary first arrived at the Genesee a high bank had just collapsed and exposed a large number of human bones which the Seneca said had been buried

there long ago. Her people said that they did not know to what race the ash-white bones belonged. These ancients, it was thought, cleared the fertile Genesee lands and then died out.

More than ten thousand acres. Owning thousands of any-
thing was hard for me to understand. The only person I
had heard of who owned thousands and thousands of any-
thing was in the Scripture. "His substance also was seven
thousand sheep, and three thousand camels, and five hun-
dred yoke of oxen, and five hundred she asses."

In the evenings, Father would say the Scriptures aloud and
mostly by heart. But sometimes of a wintry evening, he
would alter them a bit to entertain us. And he would
change his voice and move about the cabin.

We children loved the part from Job about the sea mon-
ster, and he liked to let us have our way, especially if a fierce
wind could be heard blowing outside. We would be called
upon to answer for Job and Father would be God. We
would interrupt him with the same questions every time.
Mother said she was not quite sure it was fitting that
Father should take the part of God. But he did, and he
made his voice go low, and it filled the cabin so that our
dog, Molly, would stir and look up at him.

I see this time now as if it were the present.

=

"It's all right, Molly, now. Now, all of you, do you hear that great wind out the door? Now, this voice is coming from its center. It's telling Job to stand up straight and answer some questions if he really wants to argue. Robert, stand up now. The voice is not really me, sure. I am just moving my lips. Listen.

" 'Canst thou draw out leviathan with a hook? Or his tongue with a cord which thou lettest down?' Well, canst thou, Robert?"

"Job," Robert says. "I'm Job, not Robert."

"Canst thou, Job?"

"No," says Robert.

" 'Canst thou put a hook into his nose? Or bore his jaw through with a thorn?' "

"No, God, I cannot."

" 'Will he make many supplications unto thee? Will he speak soft words unto thee?' "

Betsey says, "Who is 'he'?"

"Leviathan. This is all leviathan."

"Oh. Who is 'thee'?"

"Job. All these questions are for Job, now, Betsey."

"Oh."

"Why does God say 'thee' and 'thou' instead of 'ye'?"

"Because these were olden times, Matthew. 'Will he make a covenant with thee? Will thou take him for a servant forever?' "

"No," Robert says.

" 'Wilt thou play with him as with a bird? Or wilt thou bind him for thy maidens?' "

"No," Robert says.

"Robert, don't say 'no' every time. Sometimes just stand there. 'Shall the companions make a banquet of him? Shall they part him among the merchants?' "

Then Robert stands and looks helplessly about him.

" 'Canst thou fill his skin with barbed irons? or his head with fish spears?' "

"Now should I say 'no'?"

"Robert, say it when you think Job would have said it. Say it when you feel it's right, when you're ready. 'Who can open the doors of his face? His teeth are terrible round about.' "

Then Matthew turns to me and shows me his teeth in a fierce manner, and I show him my teeth back in a disapproving way.

" 'His scales are his pride, shut up together as with a close seal. One is so near to another that no air can come between them.' "

And Robert, who is distracted, says, "No."

"Now, Robert, sure, the Lord is not asking a question from now on. 'By his nessings a light doth shine, and his eyes are like the eyelids of the morning. Out of his mouth go burning lamps, and sparks of fire leap out. Out of his nostrils goeth smoke, as out of a seething pot or cauldron. His breath kindleth coals, and a flame goeth out of his mouth.' "

" 'Nessings'?"

"Like little fens. Secret, watery places."

"Say the part about iron and brass." I had always loved the part about iron and brass.

" 'He esteemeth iron as straw, and brass as rotten wood.' "

" 'The arrow,' " I say.

" 'The arrow cannot make him flee: slingstones are turned with him into stubble. Darts are counted as stubble: he laugheth at the shaking of a spear. He maketh the deep to boil like a pot: he maketh the sea like a pot of ointment. He maketh a path to shine after him; one would think the deep to be hoary.' " Father stops. "Tell the end for us, Mary. What Job says."

" 'I know,' " I begin, " 'thou canst do everything, and that no thought can be withholden from thee. Who is he that hideth counsel without knowledge? Therefore have I uttered that I understand not; things too wonderful for me, which I knew not.' "

One morning when I started to rise from our pallet, Hiokatoo rolled over, touched my hair, and stopped breathing.

After a time I went to the doorway and then walked through it and looked to see if I could discern his spirit as it left his body. I had seen him coming back to me across a field after the Sullivan campaign. I always knew he would leave me that same way, all his vigor now returned, concentrated in his spirit since he had shaken himself free of his wrinkled skin, wasted lungs, shriveled penis, and softening bones. He was going away, he was crossing our fields.

But he had left his tomahawk behind. What would he do without it? Learn new ways.

AND SHE tolerated it when Hiokatoo, at the insistence of his relatives, was buried with the tomahawk and a scalping-knife, a powder flask, flint, a piece of spunk, a corncake, and a cup.

Let those living who are still concerned with powder flasks and flint bury those whom they consider the dead. Let them bury your dead body this way if they so wish. What has your freed spirit to do with these things now?

Three days after his death, I heard Hiokatoo's distinctive voice. He said, "But my freed spirit was partly formed by flint and a certain tomahawk, by corncakes and a special brown cup. They were the kindling by means of which my spirit flared up and burned in the world."

And he said, "So as Hiokatoo and none other, I forever bear earthly marks as part of my formal dress even in this festive space where I now reside."

NONE of the Seneca asked her why she was staying, but some of her white acquaintances did. She answered them with stories which they did not understand.

Why would she not want to rejoin white society, they wondered. Hiokatoo was dead. Why not find her relatives, some of whom were rumored to be in Virginia? She had no notion, some said, of what life would be like in Richmond, of peach silk dresses, crystal and pewter, hydrangeas and vines hand-painted on china. She had dusky eyes, which in certain lights looked the color of hazel; she had luxuriant auburn hair. She would be thought of, in a place like Richmond, as an Exotic. Surely she would marry. She was wealthy in land; she could still keep it. A man would find her strange tales charming.

And while they were thinking these thoughts, she was telling them odd and true stories.

ONE STORY concerned a Seneca who ambushed a white man named John O'Bail. The Seneca, named Corn-planter, made O'Bail strip off his clothes and then terrified the white man by casting aside his own garments—surely some grotesque wrestling match was about to occur.

But Corn-planter leapt up to the top of a boulder and gestured widely with his arm. He asked O'Bail if he had not in his young days passed through the Indian settlements that lay between the Great Hudson River and Fort Niagara, and the shivering white man said that he had. Corn-planter further asked if the man had not loved a certain "squaw" in one of the settlements, a certain woman whose name was Earth-shaker. O'Bail's mouth dropped open, and he thought that this was his death, that the Indian must be a relative of Earth shaker's. He had indeed become infatuated with her and had loved her for nights at a time on many trips.

Then the Seneca drew himself up and said, "I am your son." He paused and then said, "And you. You are my father!"

O'Bail stared and Corn-planter went on. He said that his name was also John O'Bail, a name given him by Earth-shaker, his mother, but that he was commonly called Corn-planter.

"My scouts," he said to his still staring father, "have been watching you, keeping track of your where-abouts since you came into this area many months

ago. I was eager to see you, to greet you in friendship. I have taken you by force and in this sense you are my captive, but today we stand as equals in our nakedness, father and son. I, your colored-skin son, revere you. I wanted you to know this, but whether you live with me or with your white sons, that is your choice."

Father and son spent many hours talking together. Then old John let it be known that he wished to live among his white family, and his son said, "Let it be accomplished. We will escort you home."

This was the Corn-planter story.

AND THERE was a story about a surgeon in the Colonel Crawford regiment, which marched against the Indian towns of the Sandusky in July of 1782. Hiokatoo, before he sickened and died, had told her about this man, whose name was Dr. Knight.

Dr. Knight was captured with Colonel Crawford by means of an ambush, and he watched his friend and commander die a brutal death at the stake on the Sandusky Plains. Knight's face was blackened with ashes from the fire that consumed Crawford, and he was thus given to understand that he would lose his life in the same manner the next evening on the Lower Sandusky.

Two Delaware set off in the rain for the new place of

execution with the prisoner, and when they came to camp for the night dry firewood was scarce, so they released the doctor briefly to help them gather kindling. On the first small foray he delivered enough dry sticks that the Seneca were able to set to work building a fire. But the surgeon had also picked up a log which he had dropped just inside the clearing, and while his captors bent over their fire he retrieved it: with two urgent and powerful blows he felled them.

Then, deftly, and using the Delaware's own scalping knives, he decapitated first the one and then the other, after which he laid the scalping knife to the crowns of those severed heads.

Dr. Knight, Mary would tell her audience, by means of walking in water whenever he could, made it back to his people without a single difficulty. And some who know said that two scalps hung above his doorposts until the day he died.

What she did not say was that the person who had blackened Dr. Knight's face was Hiokatoo himself, the man whom she had married.

BETWEEN these zones, these latitudes, on these dates, in the midst of these weathers, a midworld was forming, and what odd lineaments: love-in-trading and shocking reunions; the sharpest of scalping knives in the hands of a literate white surgeon.

With which group should I live? What was a group, now,
on the Genesee?

I consider my experience; almost every day, as my death
approaches, I consider the stories of Corn-planter and of
Dr. Knight.

IN HER later years she buried three sons. If she had thought to stay in one place for the sake of her children, some of them took no thought about remaining for her. They left her there, in that place. These were the sons.

The daughters—wise Jane with her seven children, bold Betsey with seven, and lighthearted Polly with just three young ones and no signs of more—lived peacefully within eighty rods of her.

So that sometimes I thought of writing, if I could have written, these words: "I hope that you will all have some daughters. Have at least one daughter."

VIOLENCE—the hatchet and the knife—and the drinking of ardent spirits marked her sons' deaths, a violence that seemed senseless, that pointed nowhere. Mary often imagined the deaths as silent set-pieces,

since she had not herself been present when her boys received the blows that dispatched them.

Thomas and Jesse died in separate incidents, both at the hand of their brother, John. Two Squawky Hill Indians later killed John. All three of them had become heavy drinkers and drunken fighters. Her flesh and blood, the spirits she had cared for over many years, left her.

I had been touched by, I had recoiled from many acts of violence in my life, but until the deaths of my sons I had not known what violence was. Just before our capture, an older friend had told me, out of my parents' hearing, that to "know" in the Bible meant to "sleep with."

To have one's sons kill each other?

How could I have stopped it? Until now I had in some way or another managed almost everything.

Now, in my old age, have I slept with violence.

SHE SAW in detail the eager faces the boys had shown her as babies. Those curious, small faces where one expression seemed to dawn and then break up and give way to another, those faces floated now always before her eyes.

IN THE first of the tableaux, Thomas comes to pay his mother a visit. He is approaching her house, where he will find not Mary but his brother John. The first thing she imagines is his walk, which is the walk of the proud and intoxicated person who likes to think of himself as in all ways competent. Thomas has drawn himself up as if he is holding his breath, his chest is stuck out, and his hips sway just a bit, for they must absorb the shock, their locomotion must make up for the rigidities he has imposed on his body.

He mouths words to John, who has some renown for curing ills with herbs and whom Thomas both envies and dislikes and has called a "witch" and an "evil spirit." John mouths words back. Thomas speaks again. Then John picks up his tomahawk, grasps Thomas by the long hair he has always and openly scorned, drags him out the door, and twists the hair so that Thomas must face him.

John killed Thomas with one blow to the head. Thomas was fifty-two years old. John was forty-eight.

IN THE second tableau Jesse, who frequently took offense at the way he imagined John treated him, is drinking spirits from a bottle. John drinks also as they help one of Mary's sons-in-law, George, and a white man named Mr. Whaley slide lumber down a hill to a river. The staggering Jesse starts a fistfight over some foolishness with George, who is soon laid low. All this time, John is silent and glowering. After Mr. Whaley mounts his horse and rides off, Jesse and John speak words and John draws a knife, which Jesse tries to take from him.

When the doctor examined Jesse's corpse, he found that there were eighteen stab wounds from his brother's knife.

THE LAST death, that of John: she saw the dumb show in a fading light.

The figures are silhouettes. Three men, John and two Squawky Hill Indians, ride on horseback through the woods. They drink: one slips from his saddle; one falls asleep. They recover themselves; they keep riding; they do not speak words. But then the haze around the silhouettes clears, and Mary plainly sees the two from Squawky Hill dismount and drag John down from his saddle.

Next, one of the two lifts a hatchet high in the air and brings it down with great speed on her son's head.

To this day, some Seneca as well as some of the white river people say they do not know for sure why these things happened to my sons. Are they blind?

SHE BURIED John in a little graveyard on her land. She buried him as she had buried the others, with ceremony. There was a modest casket, pallbearers to carry it across a field, and a tall, hollow-cheeked officiant who bore the name of Great Dusk-Owl.

The casket sat next to two other graves. The wind caught the mourners' hair and clothes and blew them aslant, upward.

Great Dusk-Owl moved his head back and forth. Though his eyes were sunken he was all alertness. He grew still and then opened his mouth and closed it again and continued turning his head from side to side. Once again, he grew still.

"These men," he said, "died in a time of peace. Brother raised his hand against brother; tribesmen raised their hands against a tribesman. But when these three died, they were already nearly lost to us, for they had been drinking spirits with no restraint. They had given up the clear minds the Great Spirit gave them."

He paused and then said, "When people throw out their clear minds, they throw out their freedom of

choice. Bad things will happen. Dreams will stop their visitations. Corn will not be properly tended. People will scare off their own game because of their drunken stumblings. Wild laughter will turn to groans and tears. Sleep will bring no real refreshment."

Great Dusk-Owl turned his cavernous being toward the casket and graves and addressed them. He drew himself up; even his chin tilted up so that he had to look down at the mourners when he spoke. "What is our great departed chief, Little Beard, saying to these dead men right this minute? Little Beard is saying this: 'Cowards!'"

The members of the little group stepped closer to one another, either against the wind which blew across the Genesee or against the shock of Great Dusk-Owl's words.

But there were more words. "Cowards!" he said to the signs and remains of the dead. "You were afraid to face the normal hurts of this life. It is true that the whites brought spirits and encouraged drink; it is true that this was an insult. In truth, you were part white. But you embraced the insult. You put a snake in your path. You set a cougar to devour your own venison so that you would end up starving. You tortured your relatives and friends—a thing that is of the greatest disgrace to you and so to all of us."

Great Dusk-Owl ran at the casket and the graves, flapping his arms as if he were trying to scatter crows.

"Jogo," he shouted. "Go! Get out of here! Better that in your cowardice you are gone. Better that you had eaten muskrat root when you were young than end the way you did." He flapped his arms once more, turned from the graves, faced the group, drew himself up again, and folded his arms.

THREE days after the funeral one of Mary's white tenants who had become a good friend was helping her back a load of hay into the barn.

Richard was silent until Mary said, "Is there something wrong?"

"Good God," he said.

Mary looked up at him. "What is the matter?"

"Great Dusk-Owl. Holy God."

"What do you mean?"

"His sermon."

"You mean his words at the funeral?"

"Harsh. Harsh, hard things to say on such an occasion."

"You think so?"

"Yes, I think so. And in front of you, the men's mother. What could he have been thinking of?"

"I think I know what he was thinking of."

"You do? It's beyond me. What, then?"

"I think I know what he was thinking because— it was what I was thinking. And I had told him my thoughts."

"What?"

"I had told him my mind."

"*You told* him what to say!"

I had told Great Dusk-Owl my mind. Perhaps those things were in accord with his own thinking.

RICHARD fell silent again for a time, and then he spoke. "Maybe they couldn't help the way they ended."

To this Mary said nothing.

He turned back to what he had been doing, lifting a bundle of hay from the cart, before he said, "Someone wants to write down the story of your life."

"What?"

"Someone wants to write down the story of your life." Finally his eyes met hers.

She gave him a sharp look and he shrugged; the faintest of reds was rising on his tanned cheeks and moving toward the gray hair of his sideburns. "It wasn't my idea."

"Who wants to do this?"

"His name is Seaver. A doctor. But he likes to write histories. Someone else is behind him: Daniel Bannister, a lawyer and publisher. Dr. Seaver proposed that I ask you if you would come to talk with him; the meeting could be at the Whaley house."

"Jennet Whaley's? In Castile?"

"Yes."

"I see. I also see that their plan is far advanced. Odd, that it is so far advanced at the same time the subject of their proposed history knows nothing about it. When did they come to you about this?"

Richard cast his eyes down. "Two weeks ago."

"Be careful, Richard. The hay you have stacked is about to fall on you."

She turned and spoke to her dog. Tilting her head toward Richard, she said, "Molly." Then she said, "Bite him, Molly."

Molly looked from Mary to Richard and half wagged her tail.

When on the next day he came again, this time to share a meal with Mary, he said, "I told Bannister and Seaver 'no.'"

She was in the process of serving him spoon bread with rosemary in it and bits of ham and fried apples: she set his plate down with a thud and then put one hand on her hip. He took it as reflexive of gratitude and said, "I should have told them that in the first place. You've never wanted to talk in public about what happened to you. I know that. I'm sorry."

"Richard," she said, "why did you answer them for me? The day before yesterday, which was Friday, I may not have been ready to speak out. Would that mean that yesterday, which was Saturday, would find me still not ready?"

SHE ENTERED the stand of white oak that stood along the creek. Beyond it and beyond the next clearing, if she went just south of some shrubby overgrowth, she would look down on the small cluster of houses that was known as Castile.

"Mary," her father had said.

SHE PASSED through the trees and stepped up on one end of the log which bridged the stream.

He had said, "Open your eyes. Watch where you are being led."

———

SHE BEGAN her crossing, taking short steps. Her poor eyesight led her to be careful. She looked down at her feet.

Look at your feet, I thought. Moccasins.

OFTEN in the past she and Hiokatoo had crossed this rushing water together. Only in the last decade of his life had she avoided going in this direction, because he lurched a little when he strode, and wherever he went, no matter what she said, he would do nothing but stride; she feared he would lose his footing on the damp log.

She was to spend three days or so talking with James Seaver at Jennet Whaley's. She set her face toward the stone house.

Dr. JAMES Seaver rehearsed what he would say, how he might approach Mary. He was just a little nervous, or perhaps he was trembling from eagerness.

He would at some point say, "All these years as a captive you have been drinking the nauseous dregs of the bitter cup of slavery." It sounded elegant to him, and sympathetic.

In fact, he had already written one passage about his subject, based on numerous reports he had heard.

Although her bosom companion was an ancient Indian warrior, and notwithstanding her children and associates were all Indians, yet it was found that she possessed an uncommon share of hospitality, and that her friendship was well worth courting and preserving. Her house was the stranger's home; from her table the hungry were refreshed;—she made the naked as comfortable as her means would admit of; and in all her actions, discovered so much natural goodness of heart, that her admirers increased in proportion to the extension of her acquaintance, and she became celebrated as the friend of the distressed. She was the protectress of the homeless fugitive and

made welcome the weary wanderer. Many still live to com-
memorate her benevolence toward them, when prisoners
during the war, and to ascribe their deliverance to the
mediation of "The White Woman."

THE DOCTOR was a sophisticated man. When the white-aproned Mrs. Whaley took him to Mary, who was already in the back parlor, he was taken wholly aback. She was sitting at a chair next to a table on which there was an oil lamp.

He had been trained to be observant. Normally he would have taken in all the details of her odd, hybrid garb first and committed those to memory, to the memory for which he had become famous among his friends and colleagues.

But the face stopped him. Her face. It was shining.

"Mary, this is James Seaver." Mrs. Whaley was a large woman with baleful eyes, but she was brisk. She turned her massive body about and left the small room.

James managed, "Mrs. Jemison."

Her lips parted as if she was about to respond and then closed again. She looked at him. "Please sit down," she said finally.

Neither of them spoke for a minute, and then he said, "If it's agreeable to you, I thought we might spend several hours just getting to know each other. That is, before we begin the formal account of your life. That

is, one should know, don't you think, a little about who one's biographer is?" He began, "I am a physician who—"

"Dr. Seaver."

"Yes?"

"You have been studying me. I have already studied you. I know much about you. Do you see my hair?"

"Well—yes."

"It is going gray. But for this hour, I still have it. No one has scalped me yet. For this hour, I am still able to tell you my story. You are willing to receive it. This would be a good hour in which to begin."

He stared for a moment and then said, "Of course." He opened his green-covered notebook and closed it again. "All these years—" He hesitated. "All these years," he repeated, and then rushed through the rest of his sentence—"you have been drinking the nauseous dregs of the bitter cup of slavery." He raised his thick eyebrows encouragingly, but it occurred to him that what he had just said sounded a trifle ridiculous.

"Pardon me. What are 'dregs'?"

This question startled him. "Ah, well, the sediment—the lees; ah, the basest portion of a liquid."

"In the bottom of a bowl."

"Yes."

She considered and her eyes seemed to flash. "Some should no doubt have their lives described this way, but I hardly recognize myself in what you say." Without

pausing she said, "My first memories are of my father, a door, a wall, the hills—" But then she seemed to falter.

"Yes?"

"My strongest first memory is of my father, a door, a wall, the hills, a sledge, and the snow."

"I beg your pardon?" He was struggling, trying not to stare, still getting used to her appearance, trying to take her in.

THAT night, after the first day's interview, in the privacy of the room to which Mrs. Whaley had shown him by the light of a candle, James wrote some notes:

Appearance

 complexion is very white

 wrinkles

 crimson of youth is distinctly visible

 sight is fairly dim, according to the subject— now that she would have an opportunity to learn to read again, she cannot do so

 cheekbones are high and rather prominent

 hair quite gray, a little curled, of middling length

 walks with a quick step without a staff

*I was informed by Mr. Clute that she could yet
cross a stream on a log or pole as steadily as any
other person*

*stands tolerably erect, with her head bent
forward, apparently from her having for a long
time been accustomed to carrying heavy bur-
dens in a strap placed across her forehead*

Dress

shirt, short gown, petticoat, stockings

*gown of undressed flannel, colored brown . . .
made in old yankee style, with long sleeves,
covered the top of the hips and was tied before
in two places with strings of deerskin*

stockings of blue broadcloth

*such . . . the dress that this woman was con-
tented to wear, and habit had rendered it
convenient and comfortable . . . wore it not as
a matter of necessity, but from choice, for it
will be seen . . . that her property is sufficient to
enable her to dress in the best fashion, and to
allow her every comfort of life*

English

*speaks English plainly and distinctly, with a
little of the Irish emphasis*

recollection and memory exceeded my expectations

it cannot be reasonably supposed that a person of her age has kept the events of seventy years in so complete a chain as to be able to assign to each its proper time and place; she, however, made her recital with as few obvious mistakes as might be found in that of a person of fifty

has the use of words so well as to render herself intelligible on any subject with which she is acquainted

WHEN he had finished writing his notes, he mused. How little of her lay on his pages. He had in no way captured her face.

Conventional religion he had abandoned long ago, but now a Scripture came to him: "Wisdom hath builded her house, she hath hewn out her seven pillars: She hath killed her beasts; she hath mingled her wine; she hath also furnished her table. . . . She crieth upon the highest places of the city, Whoso is simple, let him turn in hither: as for him that wanteth understanding, she saith to him, Come, eat of my bread, and drink of the wine which I have mingled. Forsake the foolish, and live; and go in the way of understanding."

WHILE Mary was waiting for him to stop staring at her that first day, she repeated her phrase for him: "—my father, a door, a wall, the hills, a sledge, and the snow."

"Your father, a wall, a—"

"Yes. I was very young. It was early morning and all else besides my father and me were still abed. I remember he with some difficulty opened the door of our house and I was standing near him and when the door finally swung inward, all I could see was white. A little of it fell straightaway into the room. It must have snowed all the night and that snow had piled up against our door. Because I was so short, I could not see over it; for me the outdoors had vanished and in its place was a wall, a sheet of white.

"Instead of getting some instrument with which to push the white aside, Father did a curious thing. He carved out a step in the wall of snow and asked me to help him make another and another. He meant it to be my way to the outdoors, for he said, 'There, now, there, and sure we have made a little step stool, a little snow ladder.'

"I must have been dressed for the cold, for he directly helped me put my foot into the first little step. 'First this step, Mary,' he said, and then the next and the next. One, two.'

"I climbed the few snow stairs, and suddenly the wall ended and there was a space between the snow and the top of our door, and I crawled out through that.

"Then I stood and looked out over all the snow on all the cold hills about our house. The fields and the trees stood white under the sun and the whiteness shone in the clear air.

"Then I laughed with relief to see Father's head appear at the space through which I had come. He pushed something out that I can't recall ever having seen before, a little sledge which he must have made as we slept, with a heavy rope at the front. Next, he dug his hands into the snow and started pulling himself out, squeezing through the small opening and slithering about on his stomach.

"We two had come up a little snow ladder which we had made ourselves. We had a small sledge. Having climbed the white dead-wall we left the smoky, dark air behind in the cabin: whatever hold it had on us seemed a thing that belonged to some fast-dissolving time and place.

"And I felt that all that lay outside was ours and that the way it lay was ready."

THE WHITES prevailed upon some of Mary Jemison's Seneca friends and family to sell their lands and relocate to the Buffalo Creek Reservation. In 1831, Mary sold her own tract and also moved to Buffalo Creek in order to be among her people.

She died on September 19, 1833.

ACKNOWLEDGMENTS

THIS book is a work of fiction based on historical personages and events. Portraits of Mary, the Seneca, the blacks, the Shawnee, the whites, the French, and others in this book are not intended to re-create actual characters, races, or nations as they at one time existed. I invented freely and extensively.

My greatest debt is to the historical Mary Jemison/Jamison. She gave me the bulk of my book's plot: it was her life story, her life's work. I am also grateful to her for telling her story to James Seaver; she knew he would write it down.

The "plot," then, some descriptions of historical events, many details, and the basic content of a few speeches are drawn from the written account I read, *A Narrative of the Life of Mary Jemison: The White Woman of the Genesee,* by James Everett Seaver, M.D.; revised by Charles Delamater Vail, L.H.D. (20th ed., New York: American Scenic & Historic Preservation Society;

printed by Harper & Brothers, 1918). That book was first published in 1823.

Scriptural quotations are from the King James version of the Bible.

My research in many works contributed to this book. I found information to do with Aharihon, the (vampire) Skeleton, and the False Faces in Anthony F. C. Wallace's *The Death and Rebirth of the Seneca* (Vintage). Frederick Drimmer's introduction to *Captured by the Indians: 15 Firsthand Accounts, 1750–1870* (Dover) was helpful on the matter of scalps and scalpings. *Parker on the Iroquois* (Syracuse University Press), by Arthur C. Parker, was the source of some details of corn and food plants. The lines about Kautam on page 178 as well as the lines about slavery and the italicized material on pages 204–206 and on pages 208–210 are taken almost verbatim from the Seaver account. Professor Timothy Shannon and Professor Elizabeth Richardson Viti at Gettysburg College graciously provided me with technical help.

The Wallace Stegner Fellowship at Stanford University and the Boyer Chair in Poetry provided by Gettysburg College gave me time to write; I am grateful. Thanks also to the Pennsylvania Council on the Arts.

I would like to thank the following persons for the generous help, present and/or past, that made this book possible: Jeffry Spencer, Jill Jansen and Stanley Steenmeyer, Judith and Walter Marquis, Carol and Huntington Small, Joan and John L'Heureux, Baird Tipson,

Anne Bucher Lane and Will Lane, Stephen Quint, Leah Hager Cohen, Annie Dillard, Lori Taylor, Linda and Larry Taylor, Erin Hosier, and Meredith Blum. I am especially indebted to Betsy Lerner, Sonny Mehta, and Deborah Garrison.

Finally, I am ever grateful for the support of my family: Aimee Larsen, Patrick Cowan, and my matchless husband, David Cowan, continue to sustain me.

A NOTE ABOUT THE AUTHOR

DEBORAH LARSEN grew up in St. Paul, Minnesota, and currently resides with her husband in Gettysburg, Pennsylvania. Her collection of poetry, *Stitching Porcelain,* was published in 1991, and her poems and short stories have appeared in *The Nation, The Yale Review, The Quarterly, Oxford Magazine,* and *The New Yorker,* among other publications. She has been a Wallace Stegner Fellow at Stanford and a Wallace Stevens Fellow at Yale, and teaches creative writing at Gettysburg College, where she holds the Merle S. Boyer Chair.

A NOTE ON THE TYPE

THIS BOOK was set in Adobe Garamond. Designed for the Adobe Corporation by Robert Slimbach, the fonts are based on types first cut by Claude Garamond (c. 1480–1561). Garamond was a pupil of Geoffroy Tory and is believed to have followed the Venetian models, although he introduced a number of important differences, and it is to him that we owe the letter we now know as "old style." He gave to his letters a certain elegance and feeling of movement that won their creator an immediate reputation and the patronage of Francis I of France.

Composed by Creative Graphics,
Allentown, Pennsylvania
Printed and bound by
R. R. Donnelley & Sons,
Harrisonburg, Virginia
Designed by Virginia Tan